TABLE OF CONTENTS

Walter Foster Publishing, Inc.
3 Wrigley, Suite A
Irvine, CA 92618
www.walterfoster.com

INTRODUCTION...

Can you imagine a world without color? Black and white skies and clouds, grey streams and woodlands would surround us. What a dismal picture that presents.

Even though we tend to take color for granted because we experience it with no mental effort, it is a very individual subject. Not all of us like the same colors. We show our preferences in the ways we decorate our homes and the clothing we select to wear.

Color also creates emotion and can be either soothing or exciting, stirring or calming. You would never see a hospital room painted red. On a cold winter day we think of the warmth of the red/orange flames in a fireplace. During the heat of summer we imagine the cool blue-green of a pool of water. Light and pastel colors are usually more comfortable. A room painted with a dark color can be heavy, suppressive and suffocating. We see and use color daily without giving it a thought. If there happens to be a dramatic and unusual sunset, however, all eyes are turned skyward, art lovers or not.

As artists, we cannot take color for granted, as it is one of our major tools. We must understand it and organize it so that we can use it properly and wisely in our paintings. No matter how we organize it, there will always be some personal influence in the way we interpret and display it. First, however, we must understand it before we can organize and use it.

So, what is color? How is color produced? Color is a sensation produced by the action of the white light rays received by the retina of the eye and interpreted by the brain. These white light rays, traveling from the sun in varying wavelengths contain all of the beautiful color that we see in our world of viewing. We have a very complex system for receiving these rays, and through the marvels of sight, we see them as colors.

These same light rays create our world of form too, as there cannot be any shadow or dark areas without light to create them. So . . . light rays create color and form. Without light, we of course see nothing.

In your study of color, I would like to suggest that you DO NOT SKIP AROUND in this book, but follow it thoroughly, step by step, as it has been very carefully organized into a study progression. Hope you enjoy it.

COLOR... WHAT IS IT?

If light creates all color and form, then what is light? How does it work? According to science, light is electromagnetic energy that is produced by the sun in different wavelenghts – all of them traveling about the same speed. Due to the variation of the wavelengths, there is visible light and invisible light. The visible light is the white light that gives us our color and form. The white light is not visible to the eye until it strikes an object and is reflected back to the eye by that object. Due to the molecular structure and pigmentation of each object, the rays will be mixed, absorbed, or reflected.

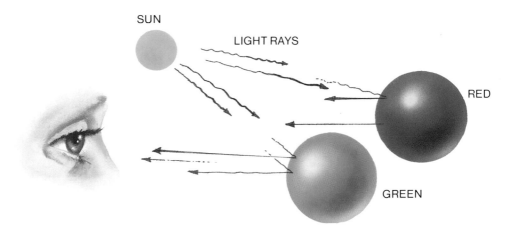

The surface of an object also affects the light rays that are reflected from that object. If the surface is shiny or glossy, it will reflect more brightly than it would if it were dull or satin finished. The bright highlight that we see on a very glossy object is the reflection of the light rays and light source.

Dark-appearing objects absorb more light rays and therefore reflect fewer light rays back to the eye than do light appearing objects. This absorption of the light rays creates the illusion of a deeper, darker color. Lighter colored objects reflect more rays and give off much more brilliance of color and intensity of highlight.

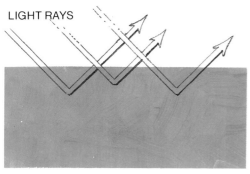

CADMIUM ORANGE

Lighter and brighter colors reflect more light rays.

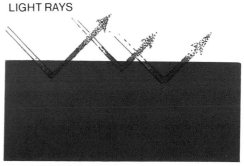

CADMIUM RED DEEP

Darker and deeper colors absorb more light rays.

Sir Isaac Newton, while working on a telescope, noticed that sunlight (white light), was broken into different colors when it passed through a prism. This prism is a simple triangular glass object that has the ability to separate the light rays into individual colors. These are the colors of the spectrum. This spectrum is the same one we see in a rainbow. When the sunlight shines through falling drops of water at the proper angle, the drops break up the light rays, creating the spectrum and we see a rainbow. The water drops create a natural prism by reflecting and refracting the light back to our eyes.

Light is broken into individual colors by the prism, and Isaac Newton noticed that there were seven of these colors. These colors were red, orange, yellow, green, blue and a color called indigo, and then violet.

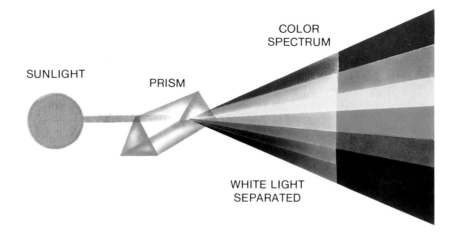

COLOR SPECTRUM

SUNLIGHT

PRISM

WHITE LIGHT SEPARATED

In order to prove the theory, Isaac Newton projected these colors back through another prism and the result was white light again. Many scientists became aware of and interested in Newton's discovery and, through their experiments, discovered that other colors could be created by mixing different combinations of red, yellow and blue. These colors – red, yellow and blue – became the three primary colors that are used in the color wheel of art. By intermixing colors on the color wheel, we can mix a vast array of colors, but we cannot mix the three primary colors – red, yellow and blue – in the same way that we might mix a green or a purple. Newton's studies were with light rays and not with paint pigment. There was no white or black that are so important in today's world of paint mixing. Our pigments of paint are solid substances ranging from transparent to opaque. Each one has its own light absorption and reflecting abilities.

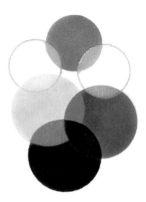

LIGHT... REFLECTED, REFRACTED, TRANSMITTED & ABSORBED

TRANSPARENT: Clear, we can see through it. TRANSLUCENT: Semitransparent, milky, foggy. OPAQUE: Cannot see through, will cover up other colors.

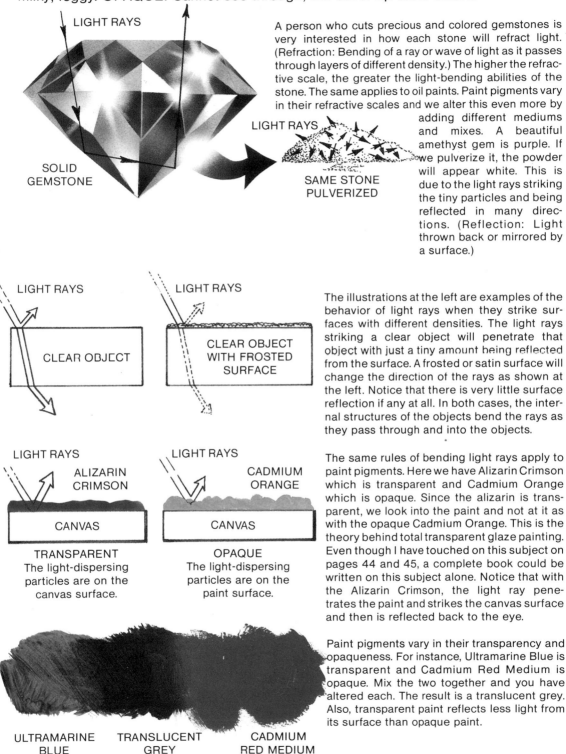

A person who cuts precious and colored gemstones is very interested in how each stone will refract light. (Refraction: Bending of a ray or wave of light as it passes through layers of different density.) The higher the refractive scale, the greater the light-bending abilities of the stone. The same applies to oil paints. Paint pigments vary in their refractive scales and we alter this even more by adding different mediums and mixes. A beautiful amethyst gem is purple. If we pulverize it, the powder will appear white. This is due to the light rays striking the tiny particles and being reflected in many directions. (Reflection: Light thrown back or mirrored by a surface.)

LIGHT RAYS

SOLID GEMSTONE

LIGHT RAYS

SAME STONE PULVERIZED

LIGHT RAYS

CLEAR OBJECT

LIGHT RAYS

CLEAR OBJECT WITH FROSTED SURFACE

The illustrations at the left are examples of the behavior of light rays when they strike surfaces with different densities. The light rays striking a clear object will penetrate that object with just a tiny amount being reflected from the surface. A frosted or satin surface will change the direction of the rays as shown at the left. Notice that there is very little surface reflection if any at all. In both cases, the internal structures of the objects bend the rays as they pass through and into the objects.

LIGHT RAYS
ALIZARIN CRIMSON

CANVAS

TRANSPARENT
The light-dispersing particles are on the canvas surface.

LIGHT RAYS
CADMIUM ORANGE

CANVAS

OPAQUE
The light-dispersing particles are on the paint surface.

The same rules of bending light rays apply to paint pigments. Here we have Alizarin Crimson which is transparent and Cadmium Orange which is opaque. Since the alizarin is transparent, we look into the paint and not at it as with the opaque Cadmium Orange. This is the theory behind total transparent glaze painting. Even though I have touched on this subject on pages 44 and 45, a complete book could be written on this subject alone. Notice that with the Alizarin Crimson, the light ray penetrates the paint and strikes the canvas surface and then is reflected back to the eye.

Paint pigments vary in their transparency and opaqueness. For instance, Ultramarine Blue is transparent and Cadmium Red Medium is opaque. Mix the two together and you have altered each. The result is a translucent grey. Also, transparent paint reflects less light from its surface than opaque paint.

ULTRAMARINE BLUE TRANSLUCENT GREY CADMIUM RED MEDIUM

LIGHT RAYS...ABSORPTION & REFLECTION

When white daylight strikes different colors of paint, each of these colors possesses its own absorptive and reflective properties just like other objects. The illustrations below show the light rays separated so as to show easily the absorption and reflection of each ray. The rays in all instances read from left to right as red, orange, yellow, green, blue, indigo and violet. I have selected three colors and one mixture to illustrate this point. For instance:

Cadmium Yellow Pale absorbs all rays except yellow which it reflects back to the eye.

Ultramarine Blue absorbs all rays except blue and red which make it an indigo color.

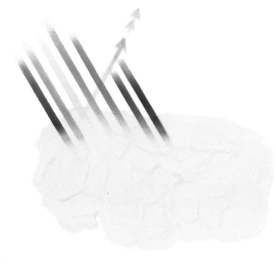

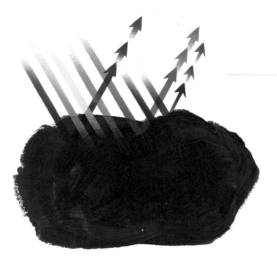

Vermillion absorbs all rays except red and a speck of yellow making it a warm red.

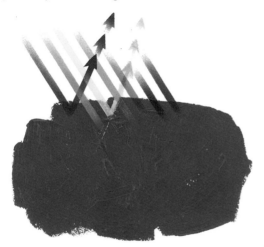

Mix yellow and blue together and we get a visual reading of green as the rays of yellow and blue are mixed.

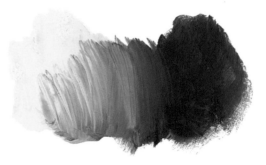

LIGHT & PIGMENT...

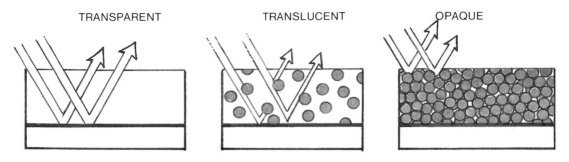

TRANSPARENT TRANSLUCENT OPAQUE

These three illustrations show how light rays are affected when they strike three different densities of paint pigment. The illustration on the left shows that rays can totally penetrate a transparent layer of paint and then reflect from another surface back through to the eye. The middle one shows that the rays are absorbed by some of the particles of paint that get in the way and reflection is altered. This is what would happen if we mixed a transparent pigment and an opaque pigment together. The illustration on the right shows that with opaque pigment the light rays cannot penetrate and are therefore changed by the surface of the paint only.

INTERMIXING PAINT...

The following illustrations show what we would see if we were to look at various mixtures of paint through a strong microscope:

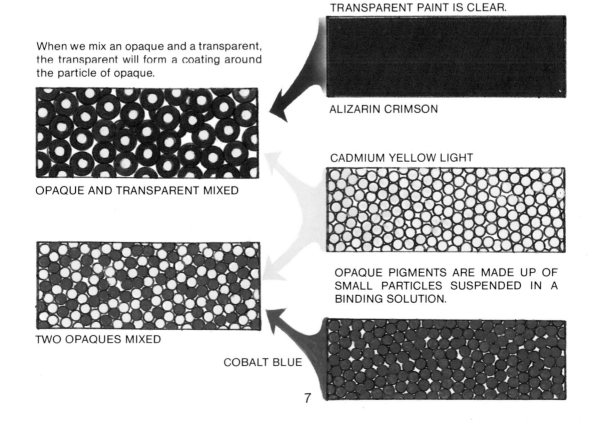

TRANSPARENT PAINT IS CLEAR.

When we mix an opaque and a transparent, the transparent will form a coating around the particle of opaque.

ALIZARIN CRIMSON

OPAQUE AND TRANSPARENT MIXED

CADMIUM YELLOW LIGHT

OPAQUE PIGMENTS ARE MADE UP OF SMALL PARTICLES SUSPENDED IN A BINDING SOLUTION.

TWO OPAQUES MIXED

COBALT BLUE

ORGANIZATION OF COLOR...

Now that we have an understanding of light and color, we must organize them into a workable system in order to use them properly. As stated earlier, the use of color is a personal and emotional experience. All of the charts and illustrations that follow are for your reference and use as a guide to using color and in no way can alter your preferences in your individual use of color. Try not to get all involved and memorize each step immediately. Instead, practice all these steps as you proceed through the book and you will be surprised how the use of these charts and systems will become second nature to you.

In 1898, an artist and teacher named Albert A. Munsell organized the information discovered by Isaac Newton by creating a color charting system that not only allowed us to see the colors of the spectrum but to use them for planning, mixing, etc. Since we can now see these colors by referring to the Munsell System, a complete understandable sequence of color study can be developed. Today the Munsell System is the most widely accepted system in the world. It is accepted by the Bureau of Weights and Standards and is used by artists and colorists throughout the world. Through the years there have been many variations of color organization conceived, but most all of them are based on the principles of the Munsell System.

The basics of this color study will assist you no matter what medium you use, as the rules of color apply to any medium containing color. To start us off on our color excursion, we have three very important qualities to learn. They are:

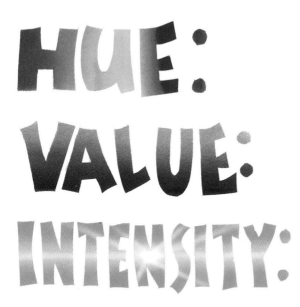

The name of the color. It's as simple as that. This allows us to distinguish one color from another by name.

The lightness or darkness of a color. Of all of these three, value is the most important to keep in mind. If the value of a color is wrong, then the color is wrong!

The purity or strength of a color. No color is more pure than when it comes freshly from the tube. Mix any other color or medium with it and you change its intensity.

The three qualities above are known as the three different dimensions that can be applied to each color. These were discovered by a scientist named Helmholz and were later used as a basis for the Munsell System.

We will get into more detail and explanation of these systems in the pages to follow. Remember, however, that these dimensions are the foundation of the color system we are going to study together.

HUE...

The first quality in the study of color is HUE. It names the colors around the wheel. Let's make a wheel of our own to use in the rest of our study. I must say at this point that all oil paints are not the same. Each brand makes its own version which will differ in color, thickness, etc. In the beginning choose a brand you like and stay with it for consistency. As you progress you can intermix. Buy the best paints you can afford at the very start. The "cheapies" are just what the term implies.

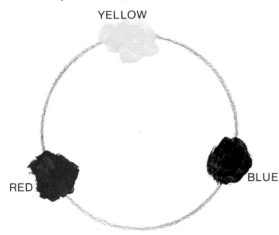

PRIMARY COLORS are the three basic colors from which all other colors are mixed. As stated earlier, we can not mix these three by intermixing other colors. For this step in making your wheel, draw a circle and place Cadmium Yellow Pale at the top, Cadmium Red Light on the left and Ultramarine Blue on the right.

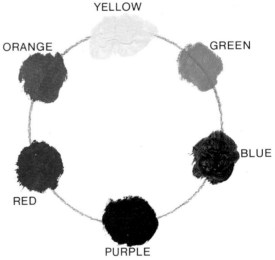

SECONDARY COLORS are the colors obtained by mixing two primary colors together. Make a green by mixing Lemon Yellow and Cerulean Blue and place it where shown. Mix Ultramarine Blue and Alizarin Crimson for purple and Cadmium Yellow Light and Cadmium Red Light for orange.

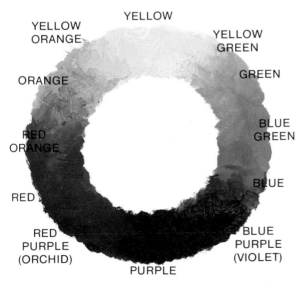

TERTIARY COLORS are the colors we get when a primary and a secondary color are mixed. Yellow and green give us yellow green, etc. Complete your wheel by working clockwise in the following manner: Between the Cadmium Yellow Pale and green, intermingle Lemon Yellow so that the other colors blend gradually into it. Between the green and Ultramarine Blue use Cerulean Blue. Mix the Ultramarine Blue and the purple. Place Alizarin Crimson between the Cadmium Red Light and purple. Mix the Cadmium Red Light and orange.

Working our way up the rest of the wheel, we add Cadmium Yellow Medium and Cadmium Yellow Light, ending up with Cadmium Yellow Pale at the top. Now we have completed a color wheel in chart form. This chart will enable us to go further in the breakdown and study of color while visualizing the twelve different colors and their relationships to one another.

WARM & COOL...

Now that we have the color wheel with the HUES in place, we can see that the colors on the red side of the wheel are considered WARM and the ones on the blue side, COOL. I know that my wheel differs from some others that you may have studied but this one is more logical to me. I find that in many other charts, all yellows are lumped together on the warm side. To me, this dosen't make sense, as some colors of yellow such as Lemon Yellow are quite cool and greenish in appearance and do not contain the red that the Cadmium Yellows do. Also, looking at the wheel, we see that yellow extends quite deeply into the cool side and therefore it is important to both sides. I break the wheel straight through the middle, with Cadmium Yellow Pale on the left and Lemon Yellow on the right.

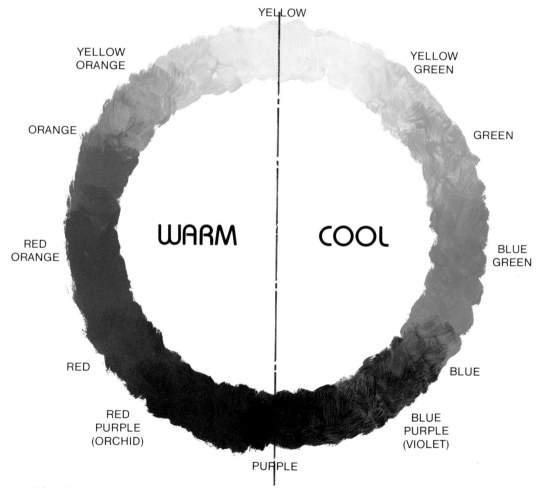

Add white to any member of the purple family and you have a tint known as lavender. Lavender can be placed on either side of the WARM/COOL wheel since it is a tint of ANY purple color.

Also, in this chart, purple is in the place that violet usually occupies in other wheels. I feel that purple belongs here because the color purple is a result of a mixture of red and blue. Violet is the shortest ray of the visible spectrum, an ultra-violet ray producing a bluish purple color. Therefore, since violet is a bluish purple, it has to rest on the cool side of the wheel. Orchid is on the warm side of the wheel since it is a bluish red. It is stronger in red than in purple. All of this can be proven to doubters by simply researching the dictionary.

10

Here are examples of painting WARM or COOL using the same subject. These paintings are good exercises. Try them as small color sketches.

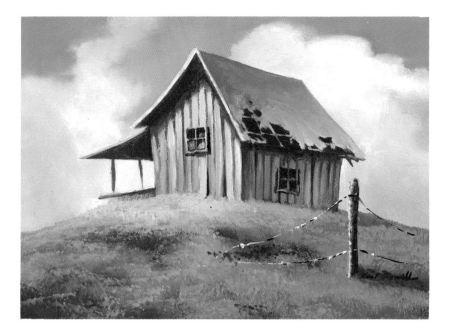

WARM PAINTING . . . Here the warm colors give a different feeling than the cool colors in the painting below. Colors used here are Ultramarine Blue, Burnt Umber, Alizarin Crimson, Cadmium Red Light, Cadmium Yellow Light, Titanium White and Ivory Black. Warm colors are selected for an afternoon feeling.

COOL PAINTING . . . Here, the cool colors give us an early morning mood that is quite different from the one above. Colors used were Cerulean Blue, Raw Umber, Cadmium Yellow Light, Lemon Yellow, Alizarin Crimson, Zinc White and Lamp Black.

Red is considered to be our psychologically dominant warm color and blue is considered to be our dominant cool color. The use of this psychological categorizing of color is very important to us as mixers and users of color. We think of red as a symbol of fire and heat and blue as the symbol of water, ice, sky and coolness. So it stands to reason that the more red a color contains, the warmer the color and, the more blue it contains, the cooler. Yellow is also considered a warming color when added to other colors, but it must be pointed out that it is also a lightening color since it is the lightest color on the color wheel and is across from purple which is the darkest color on the color wheel. When using yellow as a warming color, we are thinking of it as sunlight and therefore some yellows on the warm side actually appear to enhance the temperature of the color to which they are added. A cool yellow such as Lemon Yellow will lighten a color but will not warm that color like Cadmium Yellow Light or Cadmium Yellow Medium. Both of these Cadmium Yellows contain more red than the Lemon Yellow (since Lemon Yellow is a greenish yellow) and so will act as warming colors due to the red in them. In order to see this difference in the yellows yourself, squeeze a small amount of Cadmium Yellow Medium onto your palette. Next to it squeeze a small amount of Cadmium Yellow Light. Then squeeze a small amount of Lemon Yellow next to the other two colors. Notice how the Lemon Yellow appears greenish and the two Cadmium Yellows appear much warmer.

When thinking of warm and cool colors, we must also think of time of day. Morning colors are usually cooler than midday and afternoon colors, so our selection of paint for our palette would be different for each. Late afternoon colors are not only warmer than the other times of day, but can be used to create very dramatic sunsets. Sunsets are great fun to paint, but take care not to get into a rut and miss all of the beauty of color during the other times of day. With great care in color selection and usage, a painting at midday can be as beautiful even though less dramatic in the purple shadow values than the sunset.

For early morning, we visualize stillness and clean, crisp air with fresh colors. Several reasons for this feeling of morning are that, during the night, the absence of sunlight created cooler air and so moisture formed such as dew. This settles the dust of the day and the earth's surface cools a bit. When the sun rises, its light rays are projected to us through a cleaner, more moist atmosphere and the colors appear cooler and more fresh to the eye. The morning sky is more pastel and cooler than an afternoon or evening sky. A winter sky is cooler than a summer sky.

So, creating a painting does not mean just selecting a subject and then painting it. It means selecting a subject and then choosing exactly how to portray it. Shall we paint it in the morning light or late afternoon, winter or summer cloudy or sunny, stormy or clear? All of these decisions must be made and then we have a plan for our work which gives us a clear direction of our color selection and the mixtures we can obtain from them. Now we can MAKE the painting happen and not just hope it happens.

Here are four examples of color and palette control. Each painting was painted in a different time of day and season. Even though the scene is the same, the paintings all have a definite individual feeling. They all resemble one another and yet are different. The winter painting is the most obvious change from the others. Try these little paintings and keep in mind the time of day and season you are painting, and your paintings will reflect that mood. All of the palettes for the paintings here are very simple and limited.

MORNING: As stated earlier, the morning colors are cool and crisp. Here we see the blues of the mountain are cooler and more on the greenish side than the ones in the paintings below. For the feeling of cool morning light, Lemon Yellow was used. For warming and deepening, Cadmium Red Light was selected. Cerulean Blue was used for our cool sky and green mixes. Titanium White was used for lightening the colors. There you have it . . . a very simple palette.

AFTERNOON: Here we have more warm colors. The blues on the shadow side of the mountain are warmer and start to move toward the purple side. Notice that since this is afternoon, the direction of sunlight has changed from that above. We must pay attention to small details such as these. The colors used here are Cadmium Orange, Cadmium Red Light, Alizarin Crimson and Ultramarine Blue. Titanium White was used for lightening.

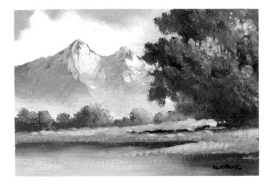

WINTER: This scene, even though it is the same scene as the other paintings, shows the most drastic changes. Not only do we have a change in the color usage, but there are some physical changes that have to be made for this season. The colors used for this painting are Cadmium Orange, Cerulean Blue, Ultramarine Blue, Titanium White and Ivory Black. Notice the white and ultramarine mixture for the shadow snow is very effective against the white and Cadmium Orange sunlit snow.

AUTUMN: Now we are really into warm colors and the wonderful feeling that comes with fall. Notice how the foliage on the tree is starting to turn to rust. The colors on the mountain are warmer and the haze more rich. I love to paint the autumn time and all of its wonderful colors. The colors here are Cadmium Yellow Medium, Cadmium Red Light, Alizarin Crimson, Ultramarine Blue and Titanium White. A very simple but effective palette.

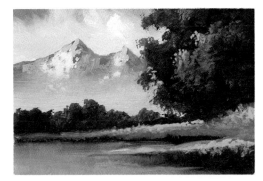

VALUE...THE MOST IMPORTANT QUALITY

As stated earlier, the first quality in the study of color is Hue. Now, we come to the second and MOST important quality, VALUE the lightness or darkness of a color. If we do not consider this quality of the utmost importance in our color usage, the results could be disastrous.

When mixing color, we add white to that color and get a TINT of the color. We have lightened the value of the color but have not changed the hue. Also, when we add black to a color, we get a SHADE of the color. We still have not changed the hue, only darkened the value. This simple chart will help clarify this point. The hue is still red, but the values have changed.

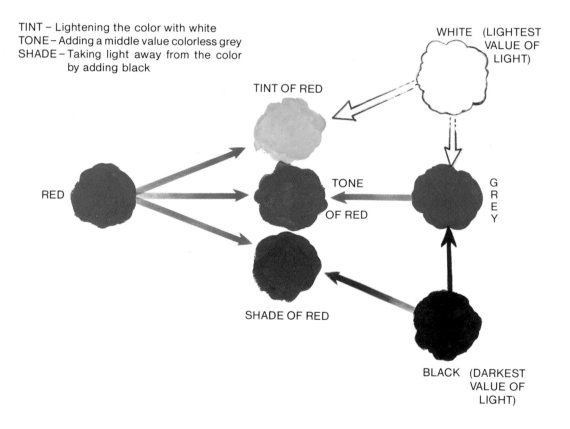

TINT – Lightening the color with white
TONE – Adding a middle value colorless grey
SHADE – Taking light away from the color
　　　by adding black

WHITE (LIGHTEST VALUE OF LIGHT)

TINT OF RED

RED

TONE OF RED

GREY

SHADE OF RED

BLACK (DARKEST VALUE OF LIGHT)

When thinking of color control, we must incorporate white and black into our palette. Neither white nor black, when used in a value scale, is considered a color as they contain only VALUE and no HUE or INTENSITY of color. They are however, tremendously important in color modification if they are used properly. Think of white as a tube of unbroken light rays (representing a combination of all colors), but also as the lightest value in the value scale. By placing the color wheel next to the value scale, we can see the comparison of light and dark. Of all the colors, yellow is the lightest and purple is the darkest.

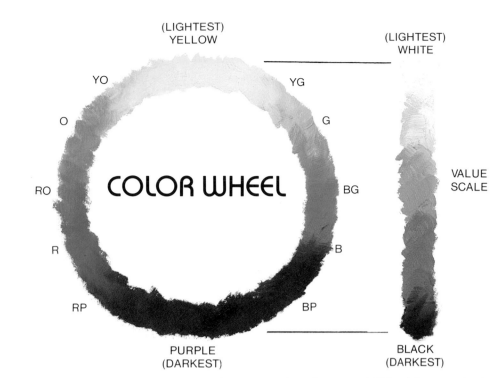

By adding white and black we get various results in our color value control. This mixing exercise is a good introduction to how white and black, and all of the greys in between, affect colors. Try it, it is fun!

Chart based on the Munsell scheme of hue modifiers with greys and neutrals.

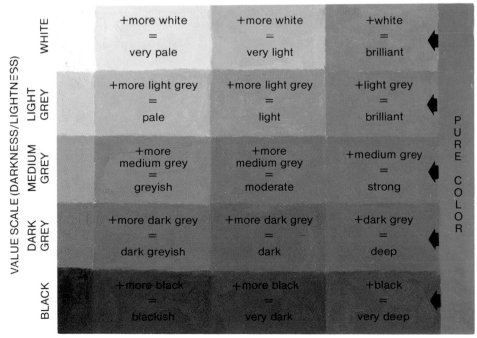

By adding lots of white to a color, our painting falls into a catagory known as HIGH KEY painting . . . add grey and we have MIDDLE KEY painting. Add black and the result is LOW KEY painting. Add both white and black and we have a FULL VALUE RANGE painting.

+ WHITE...
HIGH KEY PAINTING

By adding lots of white to our paint and keeping the value light without losing the color identifications, we are painting what is known as a high key painting. This type of color usage keeps the painting light and airy in feeling. Notice the soft value changes. If we are not careful in our color planning and use too much white, the painting can become lifeless.

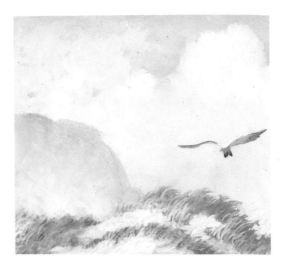

+ GREY...
MIDDLE KEY PAINTING

By adding greys, we are quieting the intensity of the color and changing the value to a deeper one. The painting becomes somewhat less bright in the colors used. This is known as a middle key painting. Here again we must be careful to plan our color mixtures well or the grey might quiet the colors too much and our painting would be drab. Keep the colors fresh.

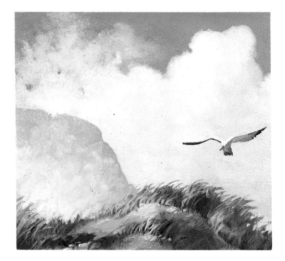

+ BLACK...
LOW KEY PAINTING

By adding black to our colors, we shade them and take them to still a deeper value range. Also we are continuing to mute the intensity of the colors. This is known as a low key painting. Now we must be extremely careful with our black for it could utterly destroy all color in the scene. Again, keep the colors fresh.

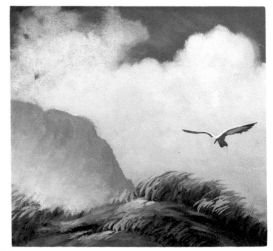

WHITE TO BLACK...
FULL RANGE PAINTING

By using both white and black (the full value range), we are painting in a more natural range of color and value as seen in nature. This is known as full value range painting. Always remember to use white and black with the greatest caution, as they could destroy the painting if either is over used. Keep the colors fresh in this painting so that we feel the sunlight and also the breezy shadows. This helps in the realism in color and viewing.

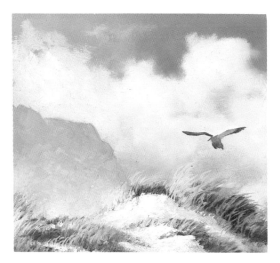

The palette of colors used for these paintings was Cobalt Blue, Cadmium Red Light, Lemon Yellow, Titanium White and Ivory Black.

THE CHART AT THE RIGHT WILL HELP YOU VISUALIZE THE LEVEL OF VALUE OF PURE COLORS IN RELATION TO THE LIGHTNESS OF WHITE AND THE DARKNESS OF BLACK. THE VALUE SCALE IS BROKEN INTO 10 SECTIONS, GRADUATING FROM WHITE, THE LIGHTEST VALUE, TO BLACK, THE DARKEST VALUE.

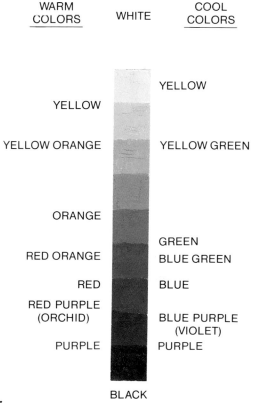

WARM COLORS	WHITE	COOL COLORS
		YELLOW
YELLOW		
YELLOW ORANGE		YELLOW GREEN
ORANGE		
		GREEN
RED ORANGE		BLUE GREEN
RED		BLUE
RED PURPLE (ORCHID)		BLUE PURPLE (VIOLET)
PURPLE		PURPLE

BLACK

VALUE MIXING EXERCISE... KEEPING COLORS FRESH

When adding black or white to colors, there are two rules to keep in mind to keep our colors fresh and not muddy. These rules are presented in the color wheel below. Try using these rules and see the freshness of your color. These are the two most forgotten or ignored rules and yet are so simple to remember.

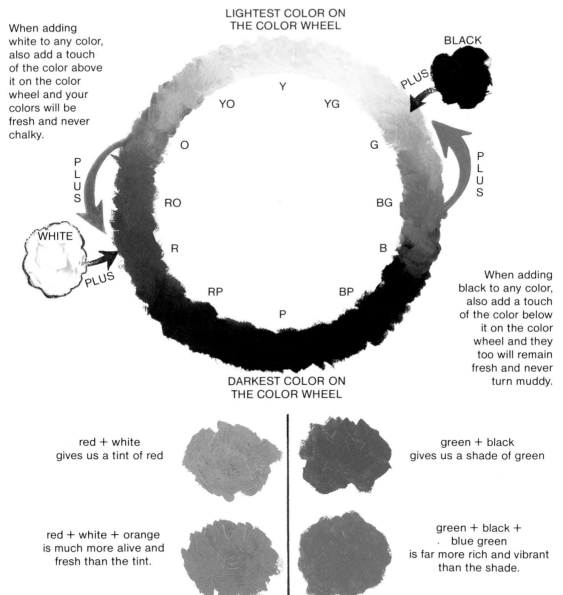

When adding white to any color, also add a touch of the color above it on the color wheel and your colors will be fresh and never chalky.

LIGHTEST COLOR ON THE COLOR WHEEL

BLACK

PLUS

Y

YO YG

O G

P L U S

P L U S

RO BG

WHITE

R B

PLUS

RP BP

P

DARKEST COLOR ON THE COLOR WHEEL

When adding black to any color, also add a touch of the color below it on the color wheel and they too will remain fresh and never turn muddy.

red + white
gives us a tint of red

green + black
gives us a shade of green

red + white + orange
is much more alive and
fresh than the tint.

green + black +
blue green
is far more rich and vibrant
than the shade.

These examples show the freshness of color by using the rules pertaining to adding white and black to colors. I must point out, however, that this does not mean that we never use a tint or shade of a color. There are times that it is necessary. All colors and mixtures are beautiful, and they only appear to be muddy because of our mixture or placement of the color.

LIGHT & DARK CREATE FORM...

As light creates color, it also creates form by organizing the darks into shapes known as shadows. The brighter the light, the greater the value range and the harder the shadow form. The softer the light, the softer the shadows and the value range is less.

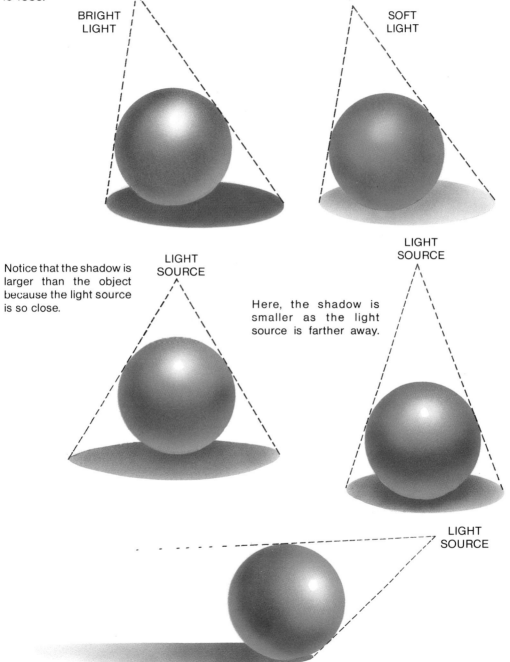

BRIGHT
LIGHT

SOFT
LIGHT

Notice that the shadow is larger than the object because the light source is so close.

LIGHT
SOURCE

LIGHT
SOURCE

Here, the shadow is smaller as the light source is farther away.

LIGHT
SOURCE

LIGHT
SOURCE

Here, the shadow is very long and projected as the light source is placed at a low angle. Shadows are most intense right next to the object that casts them and diminish in darkness as they move away. This is due to the bounce light that comes into play as the shadow moves away form its source.

MIXING EXERCISE . . . These combinations cover the complete color wheel showing the complementary colors directly across from one another. As you mix these colors together, notice the greys that result from the two complements being mixed. Also, at the top of each strip, I have added white so that the tint of the colors may be seen.

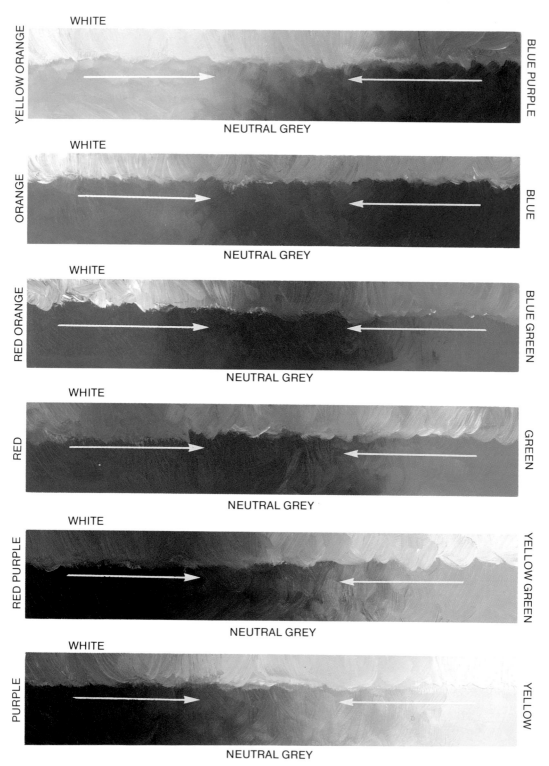

MIXING BLACKS . . . When searching colors, why not mix your own blacks for different results. Here are a few excellent combinations. Notice also the beautiful greys we get when white is added.

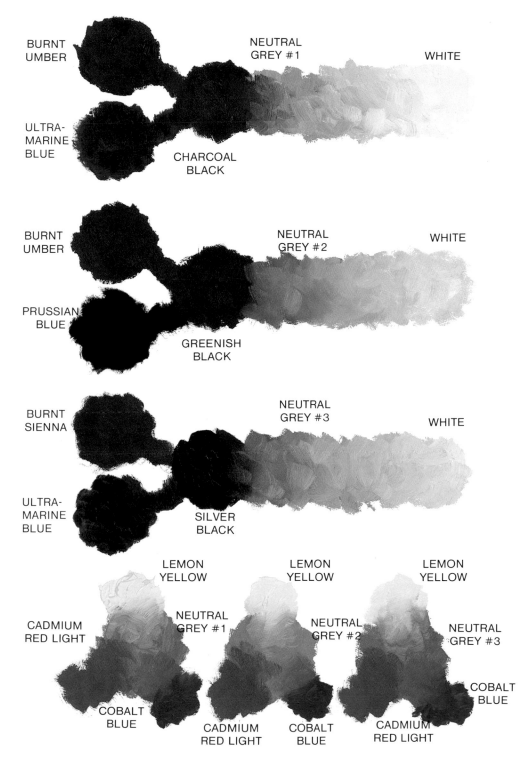

BURNT
UMBER

NEUTRAL
GREY #1

WHITE

ULTRA-
MARINE
BLUE

CHARCOAL
BLACK

BURNT
UMBER

NEUTRAL
GREY #2

WHITE

PRUSSIAN
BLUE

GREENISH
BLACK

BURNT
SIENNA

NEUTRAL
GREY #3

WHITE

ULTRA-
MARINE
BLUE

SILVER
BLACK

LEMON
YELLOW

LEMON
YELLOW

LEMON
YELLOW

CADMIUM
RED LIGHT

NEUTRAL
GREY #1

NEUTRAL
GREY #2

NEUTRAL
GREY #3

COBALT
BLUE

COBALT
BLUE

CADMIUM
RED LIGHT

COBALT
BLUE

CADMIUM
RED LIGHT

Examples of versatility of the 3 different greys when mixed with other colors.

MIX THESE COLORS and notice the illusion of black when they are in the pure state.

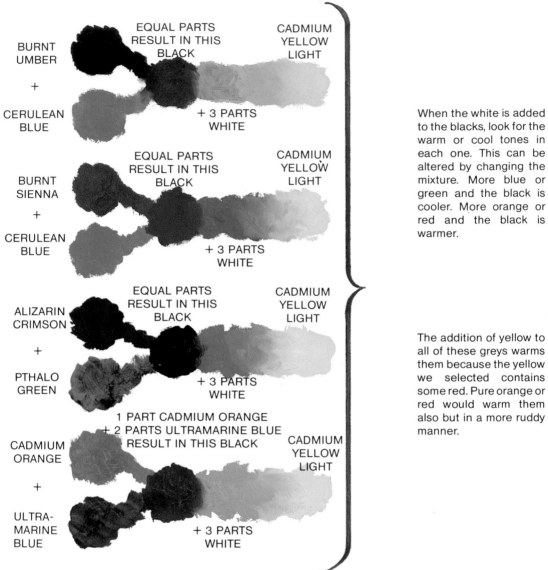

BURNT UMBER

+

CERULEAN BLUE

EQUAL PARTS RESULT IN THIS BLACK

CADMIUM YELLOW LIGHT

+ 3 PARTS WHITE

BURNT SIENNA

+

CERULEAN BLUE

EQUAL PARTS RESULT IN THIS BLACK

CADMIUM YELLOW LIGHT

+ 3 PARTS WHITE

ALIZARIN CRIMSON

+

PTHALO GREEN

EQUAL PARTS RESULT IN THIS BLACK

CADMIUM YELLOW LIGHT

+ 3 PARTS WHITE

CADMIUM ORANGE

+

ULTRA-MARINE BLUE

1 PART CADMIUM ORANGE
+ 2 PARTS ULTRAMARINE BLUE
RESULT IN THIS BLACK

CADMIUM YELLOW LIGHT

+ 3 PARTS WHITE

When the white is added to the blacks, look for the warm or cool tones in each one. This can be altered by changing the mixture. More blue or green and the black is cooler. More orange or red and the black is warmer.

The addition of yellow to all of these greys warms them because the yellow we selected contains some red. Pure orange or red would warm them also but in a more ruddy manner.

Notice the advantage of mixing your own blacks. We no longer are limited to just prepackaged blacks. Another benefit is that we can now mix a black that may be far more harmonious to the subject we are painting than a premixed black. The array of blacks that we can mix is endless. These few samples should be a good start into the world of mixing your own. The blacks we mix for color harmony will also appear more fresh than the prepared ones.

This does not mean, however, that prepared blacks are not good. It simply means that it is sometimes more beneficial to color harmony to mix our own blacks.

As to the prepared blacks, here is a little information that might be helpful to you about a few of them. Lamp Black is a cold and strong black. Ivory Black is a warm and weak black. Vine and Blue Blacks are medium in strength and on the cool blue range. Of course, this will vary depending upon the manufacturer of the paint, as they are not all the same. It would be great if they were, but they differ.

INTENSITY...

Intensity simply means the purity or strength of a color. A color is brighter in its pure state than when mixed with any other color or grey. Rarely will you use your paints in their strongest intensity (straight from the tube). There are numerous ways to change the intensity of colors. We can add white or black or different tones of grey and the color will become less intense. We can also mix the color with other colors.

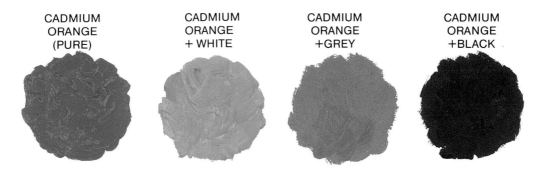

CADMIUM ORANGE (PURE) CADMIUM ORANGE + WHITE CADMIUM ORANGE +GREY CADMIUM ORANGE +BLACK

By mixing a color with its complement color (directly across the color wheel), we also can obtain varying degrees of intensity changes. These examples show several methods of changing the intensity of the color Cadmium Orange:

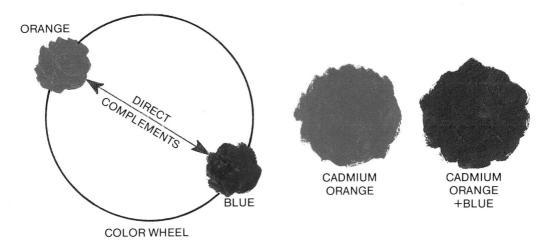

ORANGE

DIRECT COMPLEMENTS

BLUE

COLOR WHEEL

CADMIUM ORANGE CADMIUM ORANGE +BLUE

Also, as an example, Cadmium Orange is weakened and greyed by the addition of its direct complement, blue. Therefore, the intensity has been changed.

The changing of intensity is very important to the painter. In nature, there are few pure raw colors. There are lots of subtle greys, however, and we must learn to see them as we go about our color planning and mixing. The greens of grasses may be bright with sunlight, but try never to paint them bright, raw, pure tubed green. It will appear garish and out of harmony. In our mixing of colors, we now see that there are many methods employed to change the purity of a color, but the two principal methods are shown above. In review, we can say that by either mixing a color with its complement or by adding white, black, or various degrees of grey, we change the intensity of that color. Experiment with different colors and make notes with color swatches of the results. They will prove valuable.

COMPLEMENTARY COLORS...

Here we find many uses of the color wheel as a mixing guide and also for selecting our color schemes or palettes. The following examples of complements are presented to illustrate the placement of the various colors on the color wheel and the reasoning behind the selection of the different plans.

DIRECT/TRUE COMPLEMENTS...

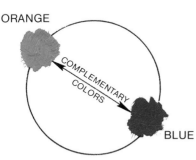

Any two colors directly across the color wheel from one another are known as true or direct complements. By adding a bit of one complement color to another, you will be greying the color in a natural way. This can result in a great array of beautiful colors thoughtfully obtained. Move these complement guide lines around the color wheel in a clockwise direction and you will discover all of the other true complements. It is another open door to a wonderful world of color mixing. The colors used here are Cadmium Orange, Cobalt Blue and Titanium White.

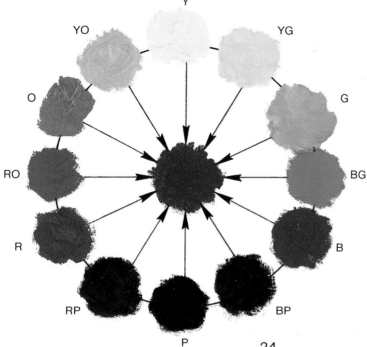

Mix an equal amount of each set of complementary colors and make a note of the beautiful neutral grey that results. Then mix an equal amount of all of the colors and make a note of that neutral grey also. Beautiful greys are our rewards. While you are mixing notice all of the tremendous variations that show up as we mix toward the final grey.

Also, at this point I must stress that it is important NOT to over mix your paint, as the colors will become lifeless and bland. Lightly mix all of your colors and they will appear fresh and lively. Also, try not to be too heavy handed in mixing as it is possible to crush some of the color granuals and the resulting color will be lifeless.

24

SPLIT COMPLEMENTS...

A split complement is made by drawing a straight line across the color wheel between two true complements. Then, from the center, draw arrows to the next lighter and darker colors. This is a split complement. This gives us a large range of color mixing. In this painting notice that red can be greyed by yellow green or blue green. A different grey would result from each color. Move these lines around the wheel to see the other combinations. The colors used here are Cerulean Blue, Lemon Yellow, Cadmium Red Light, Titanium White and a speck of Ivory Black.

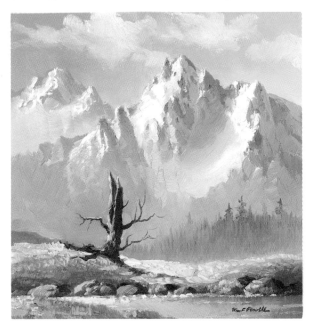

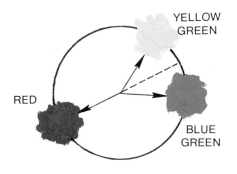

DOUBLE COMPLEMENTS...

A double complement is made up of two sets of true complements with a dividing color in between. Notice the closeness of the blue and green. There is only one color between them and that is blue green. The same applies to the red and orange. The separating color between them is red orange. Move these diagram arrows around the wheel and see the other combinations available to us. Make sure that the arrows are spaced as shown here. This color plan actually gives us even a greater range of color and mixing. The colors used here are Cadmium Orange, Cadmium Red Light, Permanent Green Light, Cobalt Blue and Titanium White.

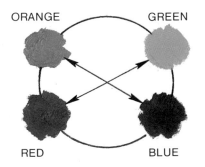

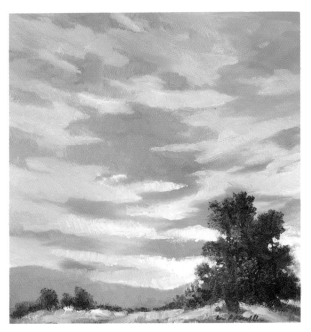

TRIAD...

A triad is made by drawing a triangle connecting the three primary colors, yellow, red and blue. This triad can be moved around the wheel giving us another wide selection of mixtures to use. Keeping our palette simple is important. As we become more proficient in mixing colors, we can add more. If we were cooking, we would not start with every seasoning in the kitchen. We would use them sparingly until we came to know them and then increase the flavors. Think of color as a visual flavor.

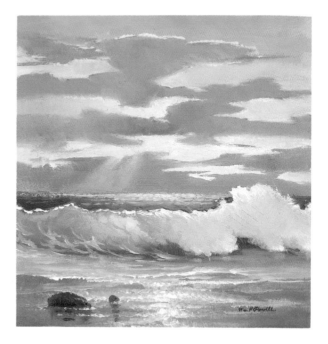

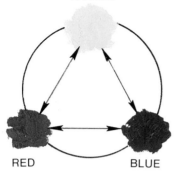

YELLOW

RED BLUE

MUTUAL COMPLEMENTS...

A mutual complement is made with one dominant color and three complementary colors on the other side of the wheel. Here, I have selected red purple as the dominant color. By drawing a line across the wheel, I find that yellow green is the true complement. By skipping one color on either side of the yellow green, I have yellow orange, and blue green. All three of these can be used in conjunction with the red purple and we are using a mutual complement plan. The colors used in this painting are Cadmium Yellow Medium, Lemon Yellow and Cerulean Blue for the yellow green mix. More Cerulean Blue is added to the yellow green to get a blue green. The red purple is a mixture of Ultramarine Blue and Alizarin Crimson.

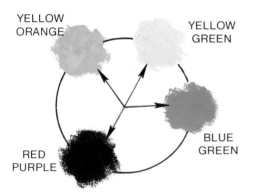

YELLOW
ORANGE

YELLOW
GREEN

BLUE
GREEN

RED
PURPLE

26

MIXING GREYS...

We have gone around the color wheel mixing true complements together and the results have been beautiful greys. Now we can set our thinking cap to mixing warm colors with cool ones and there are many, many more greys available to us. Here are a few to get you started. Mix them and keep the swatches in your notes for reference in your painting. They never grow old and you will always add to them.

WHITE AND CADMIUM ORANGE
WITH CERULEAN BLUE

WHITE AND CADMIUM RED
LIGHT WITH ULTRAMARINE BLUE

WHITE AND CADMIUM RED
LIGHT WITH PTHALO GREEN

WHITE AND BURNT UMBER
WITH COBALT BLUE

WHITE AND CADMIUM YELLOW
LIGHT WITH COBALT VIOLET

WHITE AND BURNT SIENNA
WITH COBALT BLUE

WHITE AND PTHALO GREEN
WITH COBALT VIOLET

WHITE AND BURNT SIENNA
WITH PERMANENT GREEN LIGHT

WHITE AND PERMANENT GREEN
LIGHT WITH COBALT VIOLET

Now that we have mixed these combinations of greys, notice the variation in them. This grouping is just a starting point. All of the tubes of paint at the local art supply store belong to one family of color or another on the color wheel. Therefore, we have a tremendous amount of colors available to mix and an ever greater and endless amount of mix combinations. Think grey! When starting to paint your next sky, grey the blue a speck and notice that it is not so garish and raw looking. There is a lot of grey in nature. There is also a tremendous amount of purple not only in the greys, but in nature itself. Look closely, it's there.

ANALOGOUS COLORS...

We have discussed the harmony of colors on the color wheel by complements, or being opposite from one another. Now we must take into consideration another way that color can be harmonious. This is the harmony of being analogous. This means that the colors are close and nearly like one another, yet slightly different. They are close to one another on the color wheel. Here are the colors on the wheel in groupings showing the RULING COLOR in each grouping.

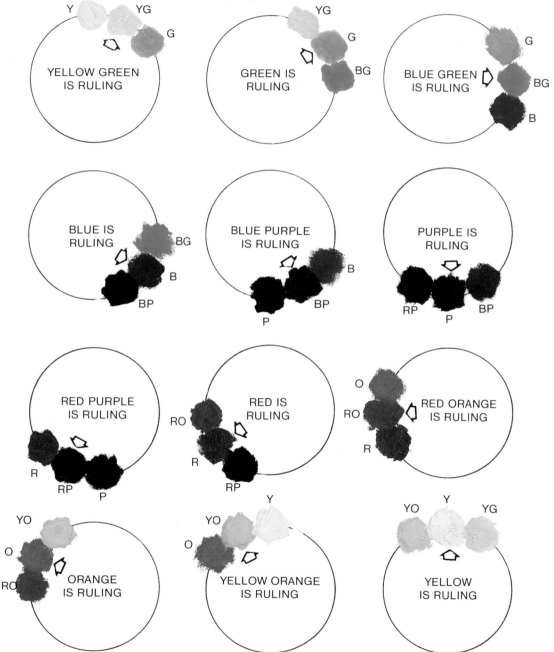

The term "ruling" simply means that the color in the center of the three analogous colors is the color that can most easily alter the others. Obviously, in the first grouping, yellow green, being in the center of the other two, can alter them. A touch of yellow green into either of the other two colors would change them. Also, most interestingly, yellow green is created by mixing green and yellow and yet it is the ruling color.

28

MONOCHROMATIC COLOR...

In water color painting, monochromatic is one color and black. The paper is white. In oil painting, the term means one color with white to lighten and black to shade. Think of monochromatic families of color also. For instance, an orange family could include Burnt Sienna since it is a deep value of orange. Yellows might be included since they are analogous to orange. Here is the same subject painted in a warm and a cool monochromatic family.

The colors used for this warm monochromatic painting are Cadmium Yellow Pale, Cadmium Yellow Medium, Cadmium Orange, Burnt Umber, Titanium White and Ivory Black. Even though more than one color is used, the painting still has the monochromatic feeling.

The colors used for this cool monochromatic painting are Lemon Yellow, Cerulean Blue, Ultramarine Blue, Ivory Black and Titanium White. Again, more than one color was used but the monochromatic feeling still comes through successfully. Try some of these on your own as they are great learning exercises and make beautiful paintings.

COLORS AFFECT ONE ANOTHER...

Sometimes we use a color and it appears wrong to us or it clashes with colors around it. This is a good example of color affecting color. Place a red ball on a yellow table next to a blue bowl. Now we really have color affecting color. The red ball will cast a tint onto the yellow table and the table around the ball will appear more yellow orange. The blue bowl will also alter the table color and the table color will affect all of the objects. Try a few experiments and notice that different colored objects absorb a little of the color of close objects. Also, color appears different when placed against different backgrounds. The following examples show this clearly:

Here the placement of pure red around a swatch of pure green shows the complements fighting each other. The colors are clashing.

Here I have added a touch of white to the red and the colors, though still somewhat garish, seem more calm than before.

By adding a touch of the complements to each other – red to green and green to red – the colors are more greyed and clash even less.

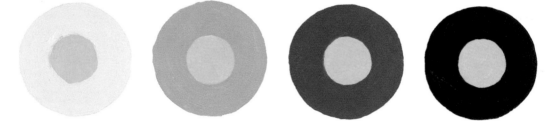

Here the same Cadmium Yellow Light has been placed in the center of these circles of greys. All of these greys have different values. Notice how the same Cadmium Yellow Light reads completely different as the values in the greys change. A very good example of color being affected by the background around it.

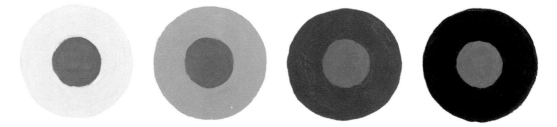

Here the same exercise has been done using Cerulean Blue. The Yellow used above is very light in value and the Cerulean Blue is deeper in value. Still the Cerulean Blue is greatly affected by the background greys. The blue in the left circle appears darker than the blue in the circle on the right. They are the same blue however. Remember this exercise the next time you find your color not reading as you want it to. Maybe the surrounding colors or values are the culprits and not the color itself.

THE ILLUSION OF DEPTH in our painting is not only attributed to the composition of the subject but also our use of color. The way we handle our colors to make them appear to either advance or recede is very important. It is commonly accepted that cool colors recede into the painting and warm colors advance. This alone will give us a good working foundation in our attempt to achieve depth in our work.

There is no magic in painting. There is only the illusion of subject, depth, distance, form, and a visual excursion around the canvas. This is why, a number of years ago when I was asked to describe the job of an artist, I coined the title of "Visual Experience Engineer". It fits well and I have even incorporated it into some of my personal brochures and cards.

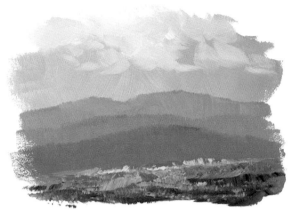

Several methods are employed to give the illusion of depth in our canvases and we have discussed warm and cool colors. Now a couple of examples are shown here to illustrate that feeling. If we wish to create the feeling of aerial perspective and distance, we add a touch of the color that is behind the object we wish to recede. For instance, if we wish to make our mountain range appear to recede into the distance, we simply add a touch of the sky color to the mountain color and they recede. The more sky color we add, the farther back they appear to go. As we move into the middle ground, we add warmer and darker colors. This helps the middle area of our painting start to move forward to the eye. In the foreground, we add the warmest and brightest highlights and the foreground moves closer yet.

In the illustration of the green spheres, notice that they are surrounded by white and therefore there are no other colors to add to them in order to make the ones in the back appear more distant. By making them physically smaller as they move to the left and overlapping one another as they get bigger, the illusion of distance and depth is achieved. This is accomplished with the use of the mechanics of drawing and perspective. The illusion of distance is enhanced greatly however by the use of color. By adding white and a little blue to the distant spheres and yellow and deeper green to the forward ones, a greater depth is achieved. If we were to place two barns in the painting – one distant and small, and one close and large – and painted them the same color and value, they would appear to be on the same plane regardless of size. The one in the distance must have the color altered to create the illusion of aerial perspective depth. Try some small color sketches and see the difference when the color has been carefully planned.

31

LIGHT ALTERS COLOR...

The color of an object can be altered by the type of light used. If we shine a blue light onto a surface, the surface color is affected by that blue light. Here are three examples of light affecting a still life.

The warm light created by the candle affects the color of the objects in our still life. The intensity of candlelight is not too strong and therefore the background is dark. The yellow in the lemon is warmed and the glow on the bowl turns greenish. The overall feeling in the painting is warm since the major light source is warm.

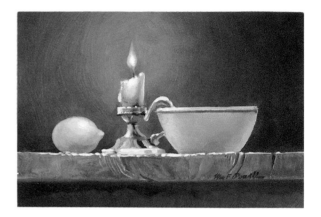

In this illustration, the daylight through a window out of our picture plane on the left is brighter and whiter than the candlelight above. The true color of the bowl and lemon are shown here more realistically. Now we can see the back wall since the light is being projected from a large source and is more intense than the candlelight that is being projected from a single focal point.

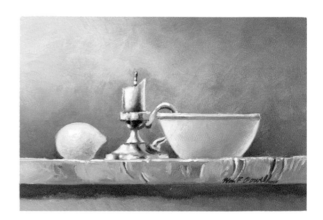

Here we have a colder light source, moonlight. Notice the depth of shadows and change of colors. The colors and the shadows are cooler and more greyish. Since this is bright moonlight, the edges of the forms still have a bit of crispness but, if the light faded some, the edges would soften. Experiment with different lighting effects and see how they change the color and even affect the mood.

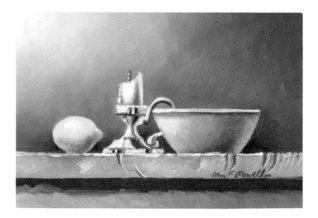

COLOR CREATES MOODS...

Color can create moods and bring forth emotional responses from we humans. Several examples of this psychology of response are the soothing colors used in hospital rooms and industrial work areas where high production is desired. Also, color is used extensively in sales presentations of products. Lots of red and warm exciting colors are used as opposed to cool or greyed soothing colors. We show a greater response to bright and warm colors. Notice the ads on television and you will see that they use warm, cheery and lively colors to lure us to purchase their products. We would certainly not be attentive to muted greyed colors.

No matter what the subject or composition of our painting, we can control the mood response of our viewers and audiences through the use of color. As painters and users of color we must learn all that we can about this wonderful subject of color and its tremendously wide world of emotional responses. With this knowledge we can create any mood we desire in our painting.

A few simple examples of emotional responses to color are as follows:
Yellow – sunlight, warming, happiness, comfort
Orange – light, warming, happiness, comfort
Red – fire, heat, excitement, danger
Red purple – darkness, intrigue, night, uneasiness
Purple – darkness, intrigue, night
Blue purple – darkness, uneasiness, intrigue, night
Blue – water, ice, coolness, calmness, moonlight, sky, distance
Blue green – water, cool, serenity, airiness, distance
Green – foliage, nature, calming, quietness, coolness
Yellow green – sunlight, richness, happiness

If we grey any of the above colors, we introduce a mood of more quietness and, depending upon the degree, somberness and discomfort. When planning your painting you must first choose the subject. Secondly, select the mood you wish to portray. This means selecting the time of day, season, and weather since these factors are very important in the type of light source you will have. Once this has been decided, these facts help us select our palette of colors. Next, test the colors selected by mixing them and painting a few mini color sketches of your subject until you have worked out all of the problems. These mini sketches are not only a valuable method of working out all of the problems of color before going on to the major canvas, but also give us a chance to experiment with composition, etc., trying different ones until the right one appears. Take color notes as you mix and sketch and you will continue to build your own library of color information. They also save valuable time and materials.

On the next few pages, I have painted a few examples of color controlling or portraying a mood.

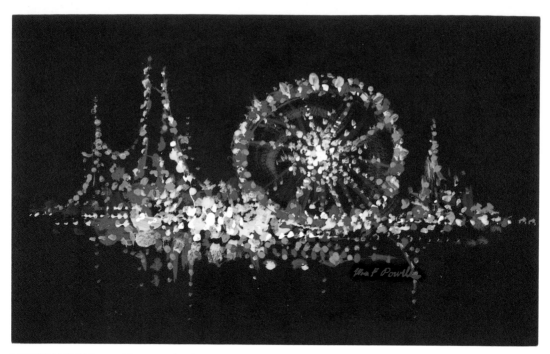

MIDWAY MAGIC . . . The use of color here gives a feeling of fun, gaiety, excitement and noise. It is a very effective use of warm yellows, oranges and reds being complemented by blue. The black background accents the intensity of the colors. The colors used here are Mars Black, Cadmium Yellow Medium, Lemon Yellow, Cadmium Red Light, Cadmium Orange, Cobalt Blue and white.

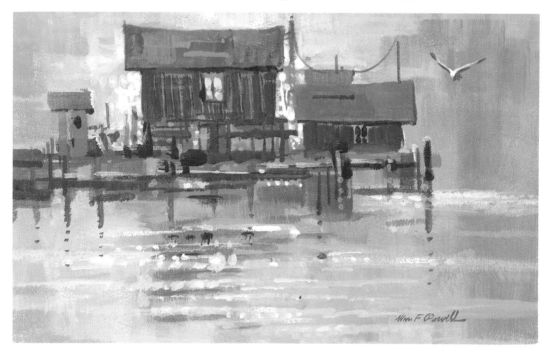

QUIET EVENING . . . By greying the colors in this painting, we are creating a quieter and softer mood. The cool and warm colors scattered throughout the painting allow a little play of color and yet remain quite still in the overall statement. Even though we have painted old buildings, the painting still has a feeling of serenity. The colors used here are Cobalt Blue, Burnt Umber, Lemon Yellow, and white.

NOISE . . . When bright, pure complementary colors are used in this manner, they are loud and unsettling.

MYSTICAL . . . Purples and blues will always create a mystical, mysterious mood.

COOLNESS . . . Lightened colors from the cool side of the color wheel create a feeling of cool softness.

WARMTH . . . Yellow and yellow oranges are associated with light and warmth.

COLOR HARMONY...

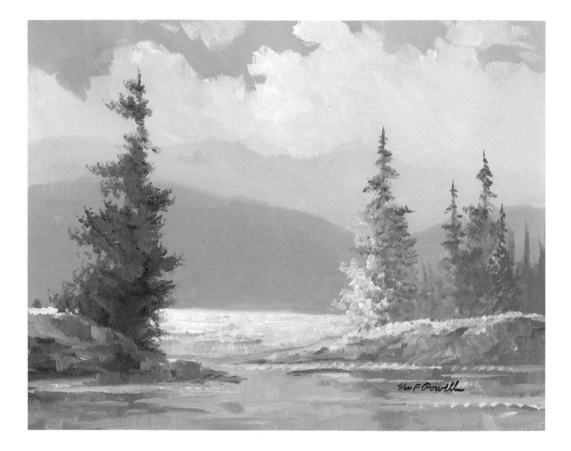

One way to create color harmony and continuity in painting is to add a bit of one color, or a selected grey, to ALL of the colors being used in the painting. When selecting a continuity color, remember that it will have more effect on its complementary color (the one across the color wheel) than on a color that is near or like it. If you wish a color to be most prominent, then do not add any of the continuity color to it and it will read fresh and pure.

This exercise can become as complex as you wish by adding more than one color but, in the beginning, I suggest that you add only one color. As you become more comfortable with the system, add more than one but remember, the more you add the less continuity you will end up with. A successful final painting means consistency of color usage. If you are not consistent with your color usage from start to finish, the resulting color harmony will not be what you had in mind.

Here is an example of a subject painted with a small amount of yellow and Payne's Grey added to all of the colors of the palette. The yellow acts as a warming agent to the overall painting. The Payne's Grey is subduing the colors. Paint one using blue instead of yellow and notice the cooling effect it has as a continuity color.

Colors used here are Burnt Umber, Prussian Blue, Ultramarine Blue, Cerulean Blue, Cadmium Yellow Light, Cadmium Red Light, Titanium White and Payne's Grey.

USING COLOR TO CREATE A FOCAL POINT...

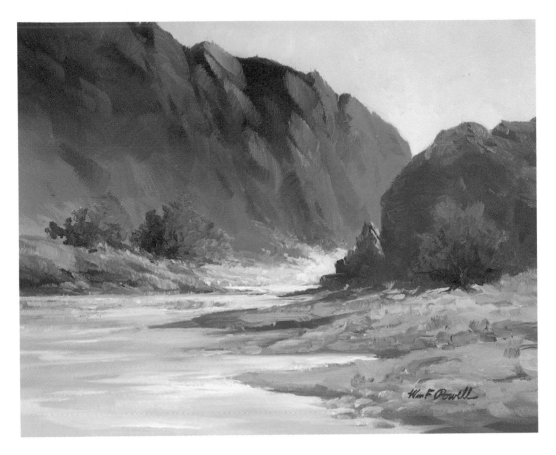

Catching the attention and directing the eye of the viewer can be accomplished with the proper use of color. The colors that we use must be chosen very carefully, keeping all three of our color qualities – hue, value, and intensity – in mind. The color selected must be bright but comfortable when surrounded by others. The value of this color must be such that it will dominate when placed against other colors. The intensity must be a little more pure than the neighboring colors.

Then we must arrange the colors in the picture plane so as to obtain an even balance between complementary colors and analogous ones.

Another avenue is to balance the selection of colors across the color wheel; therefore, not using all warm or all cool colors unless you have planned a painting for that specific selection. Playing warm against cool is always following a good natural color sense.

Also, when planning a painting with color as the main tool to attract attention, try not to place any object in your scheme in a manner that would draw attention away from the main object or area.

Here the eye is directed to the bright, light, purity of the Cadmium Yellow Light and the Cadmium Red Light. The other colors were subdued a touch in order not to detract from the main focal point of interest; in this case, around the bend.

Colors used were: Alizarin Crimson, Burnt Umber, Cerulean Blue, Ultramarine Blue, Cadmium Red Light, Cadmium Yellow Light, Ivory Black and Titanium White.

POINTALISM... A VISUAL MIXING OF COLOR

When we mix color, we usually think of mixing two or more different colors together with our mixing knife or brush until they appear to result in a single different color. This is physical mixing of color.

There are several methods of creating a visual mixing of color. One of these is a method called "Pointalism". This is done by placing dots or tiny strokes of different colors next to or on top of one another. Dots of yellow create the illusion of orange when interwoven with dots of red. The eye mixes the color when it is viewed from a distance.

If we placed blue marbles all over a football field and viewed them from an airplane, the field would appear to be blue. If we placed yellow marbles in between all of the blue ones, the field would appear to be green on our next trip over. Our eye would be mixing the colors of the marbles . . . thus, visual mixing.

Notice the variation of textures shown here. The very large strokes represent a view through a magnifying glass so that we might see the technique of interweaving the two colors. Actually, to be effective, the strokes must be very tiny.

SELECTING THE PROPER COLOR...

Select a color theme that will help present the subject and its mood. Selection and use of the wrong combinations of colors can destroy the presentation of the subject. Plan your color selection carefully so that it will also fit the subject chosen to paint. A snow scene usually requires a cool palette and we think in the blue range of colors. An autumn scene would be one of warm bronze orange reds with an overall warm tone.

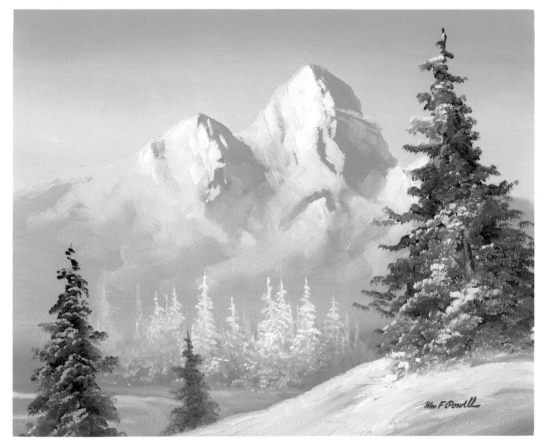

Here Cerulean Blue and Prussian Blue were selected for their cool characteristics and Ultramarine Blue for its warm. Since Ultramarine Blue is the warmest blue we have, it gives a beautiful indigo feeling to the shadows in a snow scene. The tubed Ultramarine Blue we use today has more red in it than the one used by the old masters. Ours is a modern day dye substance. The old masters ground up the precious stone Lapis Lazuli to get their Ultramarine Blue. Due to the miracles of modern manufacturing, we have several choices today. The color Pthalocyanine Blue bears a close resemblance to the clean, crisp Ultramarine Blue used by the masters. We can also buy Ultramarine in powder form and, when mixed with linseed oil, it too is less red than the manufactured tubed color. Cadmium Orange and white were mixed for the sunlight snow and Alizarin Crimson added to the white and Ultramarine Blue mixture for the purple shadows. The shadow snow on the mountain is a mixture of white and Ultramarine Blue. Using this palette, the painting not only becomes clean and crisp, but vibrant in the family of blues. Try some other subjects using this palette and see how versatile it can be. We could make a beautiful seascape from it.

PAINTING DIRECTLY FROM NATURE...

If, when painting nature, we wish to make an accurate record of the forms and colors of specific items or scenes, we must then match each color before us as closely as possible. We must pay special attention to the value of the colors.

Colors in nature are very subtle compared to the colors we purchase. Squeeze any of the bright cadmium colors onto your palette and you will see that it would be difficult to find these bright, pure colors in nature. Also, you would rarely use total black or white; they are too extreme.

As you proceed, be aware of the subtle changes of color in nature. if we look at a forest of trees, our first impression is that they are all green. Upon looking more closely, we see that there are a number of different greens in that forest and that each species of tree has its own color range. The green of an olive tree is more of a grey green than the green of the maple. How monotonous it would be if all of the trees and bushes were of the same green.

In the painting here, note the warm colors used in the foreground and the introduction of blues and purples to give aerial perspective and atmospheric distance. The sky is not always just blue, and here I have introduced a little greenish cast to help tie the total scene together with warmth. Decide where the point of interest should be and use your colors to draw attention to this area. The warm brights make the trees the point of interest in this painting. Practice will expand your knowledge of the pigments and assist you in making the selection of colors needed, the mixtures to use, and the methods of application in order to obtain the results you are seeking in the subject.

LANDSCAPE...

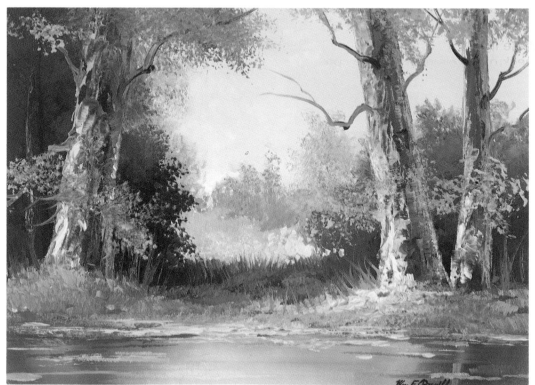

The colors used here are Cerulean Blue, Ultramarine Blue, Burnt Umber, Alizarin Crimson, Cadmium Orange, Naples Yellow, Cadmium Yellow Light, and Titanium White.

SEASCAPE...

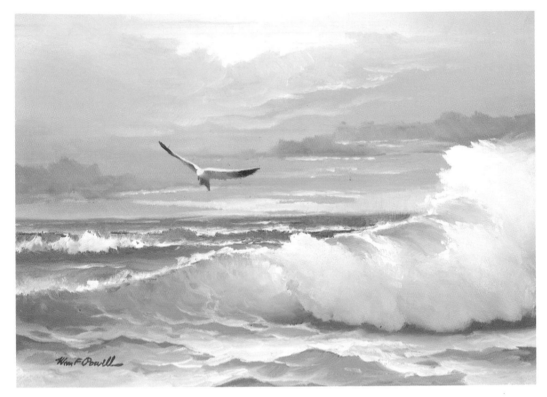

There are many color schemes that can be selected for a seascape. Here I have selected a soft, greyed scheme for a restful feeling. Naples Yellow is the main color of the light source, and all of the colors in the painting have been touched with a speck of it. This gives us the consistency of color and the feeling of overall color harmony that we discussed on page 36. Then a little Cadmium Yellow Light was used in the foreground to bring warmth and attention to this area. The warm glow in the cloud forms is created with Naples Yellow and a speck of Cadmium Orange. The overall greys in the painting are different values of grey made by mixing Burnt Umber, Ultramarine Blue and white. To these different greys, I added a mixed green, using Cadmium Yellow Light and Viridian Green. The foam is our grey mix plus white for value desired and Ultramarine Blue for color. A speck of Alizarin Crimson added to the grey will give you the purple grey used in the sky, clouds and water. The seagull not only adds human interest but is placed to enhance the composition yet not detract from the center of attention in the area of the wave form.

Remember that when painting an ocean or seascape, there is a lot of water movement. This movement creates a mist and the air is far more moist. If you are standing on a seashore watching the waves, you can see the mist being blown onto shore by the breeze. This moisture will soften our colors because we are viewing them through the mist. Let me stress at this point that the term "mist" does not mean a foggy, wet, sopping atmosphere. The day can be sunny, clear and warm, but the water movement places lots of moisture into the air. This affects the colors and we must be aware of *all* things that make the slightest difference in our painting.

Try some mid-ocean scenes with no land in sight. These scenes are great fun to paint and give us a chance to play light into the depth of waves and swells. Also with a mid-ocean scene we can be a little more stylized in our composition of the wave forms.

STILL LIFE...

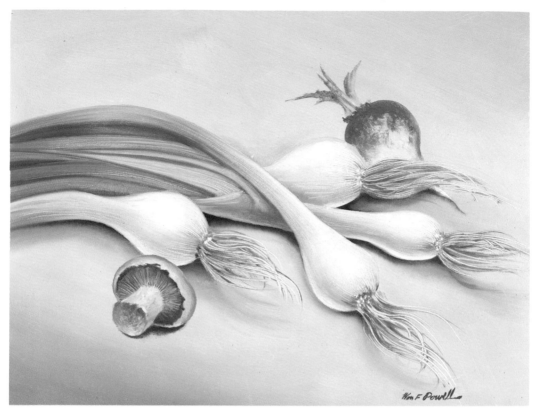

Still life painting is a great way to learn color and lighting control. After a still life has been set up, it remains constant and the light does not change as it does in nature painting outdoors.

Colors in your still life are controlled by the subjects chosen and the lighting of those subjects. In this little painting I have chosen objects that contain a great deal of white. This can be a problem if we do not keep the importance of values in mind as we mix paint and apply it to the canvas. Notice that, even though the radish has a good deal of white in it, it is a different white than that of the onions. Again, the white of the mushroom is different yet.

I have heard so many people say, "I don't want to paint still life, I want to learn to paint nature", and "Who wants to sit around and paint fruit?" They do not think that it is very exciting and stimulating to paint still life. I always tell them, "Try it, you may be surprised at how exciting and challenging it can be. It teaches us to start seeing what we are looking at in both form and color".

The techniques in painting still life vary greatly – some are painted to a photographic realism and some are accomplished with a rough impressionistic finish. The technique you select to paint with is a part of your personality. All techniques are fine. Even though the technique may vary, the rules of color usage apply to all. In order to create a form on our canvas, the color values must change realistically or we become abstract in our painting. Even if we were to paint a still life in an abstract technique, we would still have to use our colors properly. Set up a few still life subjects using objects from your home that you are familiar with. When you start painting them, you will see things about them you never saw before.

The colors used here are Naples Yellow, Lemon Yellow, Viridian Green, Ultramarine Blue, Burnt Umber, Cadmium Red Light and Titanium White.

PAINTING PEOPLE...

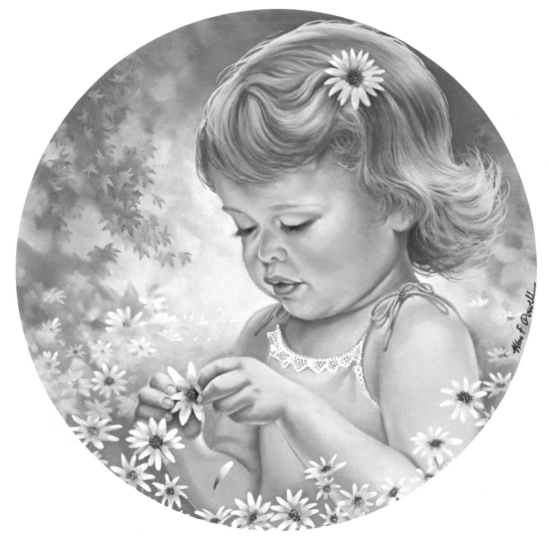

When painting people, we must not forget that the human face, head and body are objects with planes and masses as with the other forms in nature. The surface texture and coloration are unique to this subject, however.

In painting people, I like to place them in an interesting setting that not only will aid in the overall mood of the painting, but also project some of the personality of the sitter.

In painting the human subject, we must look closely at the color palette for our particular model, as each person has their own individual complexion. There is no such thing as a magic flesh mixture that will work for all people.

In this painting, "Sarah's Daisies", I started with a mixture of Cadmium Red Light (as do many portrait painters) and mixed it into different skin values using Yellow Ochre and Naples Yellow. This gives me an array of skin values that I can push around by lightening, darkening, greying, warming and cooling. In all of these steps I keep value in mind, as the face is covered with soft value changes as well as color changes. In the painting here I have remained fairly warm in the skin tones to give an overall pleasantness that will be projected into the other warm colors in the foreground and background.

GLAZING . . . TRANSPARENT USE OF COLOR

On page 7 we saw the difference between opaque and transparent paint. As artists we can turn this difference into a valuable working tool.

Usually we are told that glazing is the painting of a darker, transparent color over a lighter color in order to alter the lighter color. Also, as a means of pulling a painting together with a harmonious overall color tone, glazing is great. Today, we tend to rush our paintings and, in some cases, have been convinced that all painting must be accomplished wet-in-wet at one sitting. Nothing could be farther from the truth! Wet-in-wet is one method of painting, but only one! Taking our time and allowing our painting to dry in planned steps so we can return to that surface and apply layers of glazes is a very masterful method of painting. It does take time and much planning, so do not be in a rush. Patience is the key word when we enter the world of GLAZE painting.

Again, a complete book can be written on the methods and colors of total TRANSPARENT GLAZE PAINTING but I will briefly touch on it here.

In order to glaze, we must use colors that are transparent. There are many, but here is a list of the common ones to get you started. Use them and experiment by painting over some other colors, making notes as you go to establish your own record of how one color affects another.

Alizarin Crimson	Raw Umber	Pthalocyanine Blue
Burnt Umber	Indian Yellow	Pthalocyanine Green
Burnt Sienna	Ultramarine Blue	Viridian Green
Raw Sienna	Prussian Blue	Rose Madder

Try an experiment using Burnt Umber. It is a fast-drying color, so the exercise won't take more than a few days. Paint a solid shadow with Burnt Umber pure and solid. This will be done at one sitting. Now paint another shadow with Burnt Umber being laid onto the painting surface in thinned out layers, allowing each layer to dry thoroughly. Use a good painting medium to thin the Burnt Umber with. Linseed oil is weak and slow drying so try a good Copal painting medium. Then, varnish in between each layer with Copal varnish. Keep laying the thin coatings of Burnt Umber onto the painting surface (allowing them to dry and applying a varnish separator coat between each) until you have achieved the depth of shadow you desire. Now notice that the glazed shadow has more life than the opaque one since you look INTO the glazed shadow and AT the opaque one even though the same color was used to accomplish both.

In order to give a good example of glazing over an already dried painting, I selected the subject on page 39 and painted another to use for this example. After the painting was thoroughly dried, I painted a very thin layer of Burnt Sienna, thinned with oil, over the right half of the painting. What a difference it makes! Burnt Sienna is in the orange family and will, in some areas, grey the underpainted blue while enhancing the warmth of the light sunlight snow. Notice how even the coating is. Care must be taken not to pool the color.

Here we have a plum that is painted in total transparent steps. I have simplified these steps hoping you will try this exercise. After drawing (lightly) the outline of the subject, the first coat of color (using Alizarin Crimson) is applied thinly. Where we desire lighter areas we simply remove some of the paint, allowing the white of the base surface to show through more strongly. Use a lint free cloth to wipe away the paint you wish to remove. This method of wiping away paint so the undertone white or color shows through is one of the oldest methods of painting and has been used for centuries. It also is a method that will give us a high degree of control over our colors since we can wipe them off if we do not like them and the under painted color is unharmed.

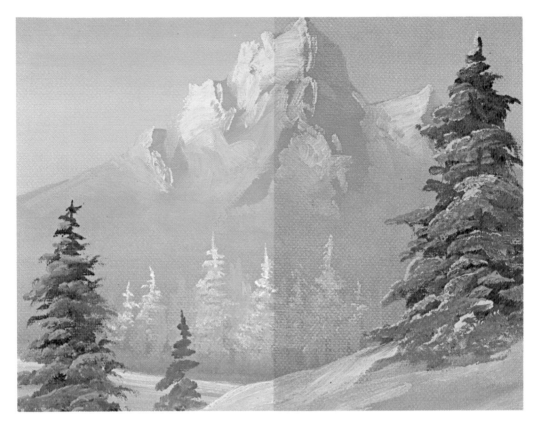

Now the painting is put away in a dust-free area to dry. After it has dried, give it a thin coating of Copal varnish and allow this to dry thoroughly also.

Next we create our purple depth by painting a thin layer of Ultramarine Blue over the plum in the areas we wish to darken and change. Wipe off all excess and again put it away to dry. Repeat the step with Copal varnish and again allow to dry.

Using Ultramarine Blue and a speck of white, mix a small amount of pale, milky blue and paint this into the areas where you wish to create the look of bloom (the greyish powdery coating on various fruits such as the plum, grape, etc.) on the plum.

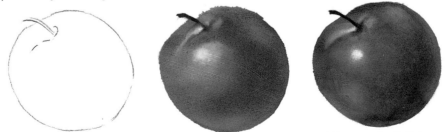

The white is opaque but, when mixed with the Ultramarine Blue and oil, it becomes translucent. CAUTION . . . Never mix or thin your paints with turpentine or paint thinner, especially in glazing. Use a good painting medium or oil. Experiment with mediums and mix some of your own. I have been using one for years that is my own concoction and like it better than any of the others offered. Try making your own but research the ingredients and what they do to the paints and how they interact when mixed together. These facts are very important to the life of the painting. Be particular as to what you use in your painting and use only the best ingredients.

Now your plum should be dry. I hope you like the results and that it has whetted your painting apetite for more total transparent glaze painting.

THE BIRTH OF A PAINTING

One of the most frequent questions asked by my students is, "How do you come up with all of those different and original paintings? Where do you start? How do you know what colors to select for each painting?"

The answers to all of these are not simple, but here are the steps that I take in planning a painting. First, of course, select a subject. Not just any subject for the sake of painting, but one that says something to you. By this, I mean one that makes you happy, sad, melancholy, nostalgic, etc. As we recall things and times in our lives, we experience inner emotions from these memories. A subtle inner emotion is just the ticket to getting started in selecting a subject to paint. It must also be a subject that interests us. This is important or we will become bored with it and either abandon the project or do a poor job in its portrayal. If we select a subject we do not really know but are interested in, we must research the subject until we are schooled in it. We cannot paint what we do not understand.

Once I have my subject in mind, I decide how I wish to portray it. If it is a landscape there are several things to consider. Do I want to use realistic or monochromatic color? Realistic or abstract portrayal?

Let's select a landscape in a basically realistic mood. Now I must decide the season and time of day. Let's choose a summer afternoon. By selecting a summer afternoon, my light source will be in the warm yellow orange range. Now that we have the type of light color selected, we can select the rest of the palette by using all of the rules we discussed in the "Complementary Colors" earlier in the book.

By selecting your palette of colors in this manner, you can use any of the tubes of paint that fall into these groupings of color on the color wheel. Next I make a few mini color sketches working out any problems with color mixes here instead of on the major canvas. In this way, we MAKE IT HAPPEN and not just HOPE IT HAPPENS!

Work out your color mixtures by using some of the guiding rules already presented in this book. You will see the positive results in your painting. Do not accept a color that is just "close enough", or the end result painting will be just "close enough" and not what you intended in the beginning. Work with your color until it works for you!

It takes a lot of thought and time to create an original painting and to work all of the problems out but the end result is well worth the effort. One of the greatest satisfactions of all is that you have created your own, totally original painting without the help of any other persons, photos, or paintings. That makes all of the hard work, both mental and physical, really worthwhile. On the following pages I have painted a number of exercises in the mixing and placement of color. I hope you like them and that you find them helpful . . .

LET'S START PAINTING ... USING A LIMITED PALETTE

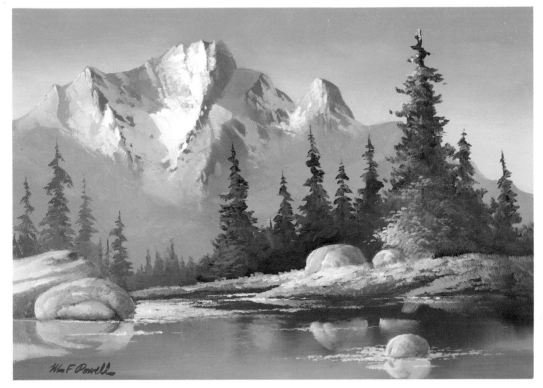

The word "palette" actually has two meanings. We use it to describe the surface we place our paints upon to mix, and we also use it to describe our selection of colors to be used in a painting. The term "limited palette" applies to the use of just a few colors. In this instance, the limited palette consists of the three primary colors red, yellow and blue. A warm and cool in each color is selected. Cadmium Red Light is the warm red selected as it contains some yellow and is on the warmer scale of reds. Alizarin Crimson is a purple red since it contains blue and is selected for the cool red. Cadmium Yellow Light is on the warm side of the color wheel and Lemon Yellow is on the cool side. For these reasons, those two colors were selected. Ultramarine Blue is the warmest blue we have since it contains more red than any other blue. Prussian Blue is a cool blue since it is a greenish blue. This is the limited palette that was used in this painting.

The swatches of paint that I have placed outside the paintings are the major intentional mixtures that are so important to the overall painting. After we have mixed these colors to the right degree, they will create the correct array of secondary colors when we intermix them. The world of secondary mixtures, as you are discovering, is endless and beautiful. A few well planned intentional mixtures can result in a tremendous amount of subtle secondary mixtures. Actually, the final painting consists of more secondary mixtures than raw intentionals. Remember that the original tubed colors selected to make our intentional mixtures can be considered as intentionals in themselves. They can be valuable in this sense to alter or intensify the secondary colors where needed. Relax and follow the steps on the next few pages and you will produce beautiful paintings. Take your time. The end result painting is the important thing, not the time card. One of the most tiring and overused questions asked is "How long did it take you to make that painting?" The right answer is "That's immaterial!" I hope you enjoy these paintings.

DEMONSTRATION 1... "HIGH SIERRA AFTERNOON"

1. WHITE +
 ULTRAMARINE
 BLUE

2. #1 +
 CADMIUM
 RED
 LIGHT

3. WHITE +
 PRUSSIAN
 BLUE

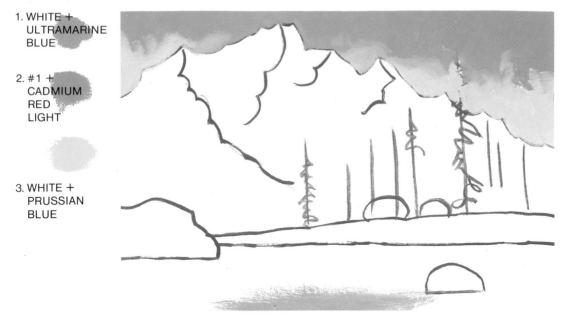

After drawing the outlines of the major subjects in the painting, mix the colors shown at the left and brush them into the areas of the sky. These colors immediately set the mood for a warm afternoon painting. Repeat them in the water too.

4. WHITE +
 ULTRAMARINE
 BLUE +
 CADMIUM
 RED LIGHT

5. #1 +
 #4

6. CADMIUM
 RED LIGHT
 + PRUSSIAN
 BLUE

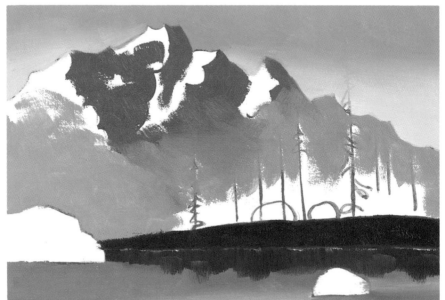

Using mixture #4, paint in the dark areas of the mountains. Then with #4 and a little #1 to make a soft grey, fininsh the base of the mountain allowing the colors to graduate and blend from dark to light grey. Use the same method to paint in the water. Then, with #6, paint the land mass and its reflection in the water.

7. WHITE +
 CADMIUM
 RED LIGHT

8. PRUSSIAN
 BLUE +
 CAD.
 YELLOW
 LIGHT

9. #4 +
 WHITE
 AND
 CAD.
 YELLOW
 LIGHT

10. CAD.
 YELLOW
 LIGHT +
 ULTRA-
 MARINE
 BLUE

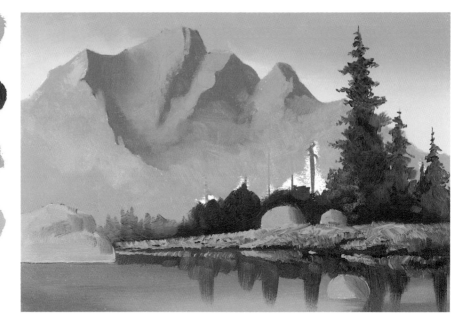

Mixture #7 is the main warming color in this painting and, as you apply it to the mountain areas, you can feel the change taking place. The warm red against the warm Ultramarine Blue sky is very pleasing and natural. Mixture #8 is used for the trees and the reflections in the water. Paint in the masses of rocks with #9. Establish the warm, soft, middle-value greens in the grasses and trees.

11. WHITE +
 CAD.
 YELLOW
 LIGHT

12. LEMON
 YELLOW +
 PRUSSIAN
 BLUE

13. #1 +
 #8

14. #1 +
 WHITE

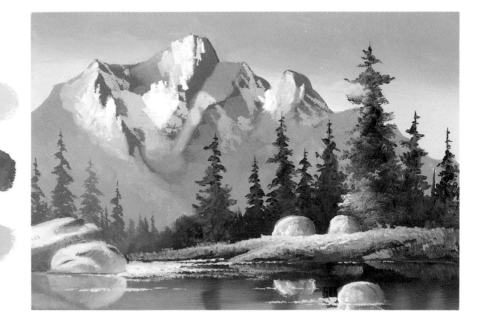

Continue painting in the lights on the trees with #10 and then accent both the tree and grass areas with #11 and #12. Paint in the distant trees on the left using #13. The shadow snow on the mountain is #14 and the sunlight snow is pure white. Do not use too much pure white as it can kill all of the other colors.

Refer to the final on page 47 and paint in as many details as you wish.

DEMONSTRATION 2 . . . "AUTUMN CAMPFIRE"

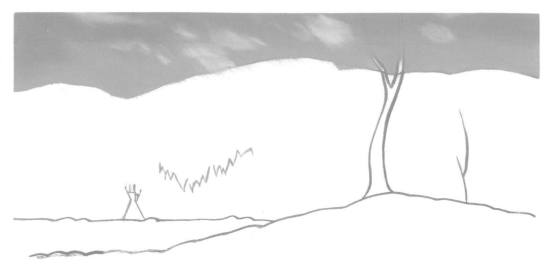

Using white and Cobalt Blue, paint the top area of the sky. Then add white and a speck of Pthalo Green and paint in the lower portion. Softly blend these two colors and paint cloud forms with white and a speck of Cadmium Orange. Now, using a very soft blender brush, soften the clouds so that there are no hard edges. At this time, the colors appear to be rather deep but remember, you are judging them against the white canvas which darkens color. They will change as you add other colors. For these exercises, I intentionally left the canvas white. Sometimes, however, I underpaint the canvas with an overall color wash to destroy the harshness of the white.

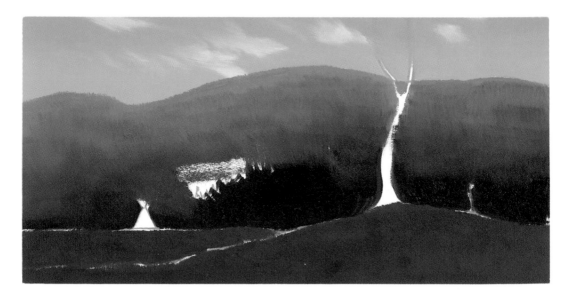

With Cobalt Blue, white, a speck of Pthalo Green and Ivory Black, paint in the top of the mountain. Then, using Ivory Black and Alizarin Crimson, paint the lower part of the mountain using vertical strokes to give the illusion of tree forms on the hillside. Now, using Burnt Umber, paint the foreground and middle ground with a thin but solid coating. This Burnt Umber coating is a perfect base color for our golden grasses and leaves to be painted into and over. Notice that even though the Burnt Umber is nearly as dark as the black and alizarin mix you painted into the lower mountain, it is warmer and seems to come forward.

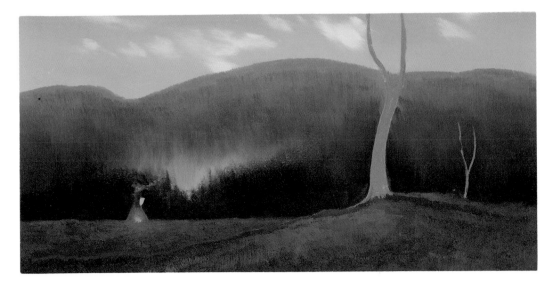

White, Pthalo Green and Cobalt Blue are used for the misty haze in the lower portion of the mountain behind the tepee. Cadmium Orange and Alizarin Crimson make up the golden orange that is painted into the middle and foreground. Notice the enhancement of the orange by the warm Burnt Umber base. Next, mix a little white, Ivory Black and Alizarin Crimson and paint in the basic tree forms. Add a little Cadmium Yellow Medium and paint in the tepee. Using Cadmium Orange and Cadmium Yellow Medium, paint the glow of the fire in the tepee. Ivory Black is used for the dark at the top. White and Cobalt Blue make the misty smoke.

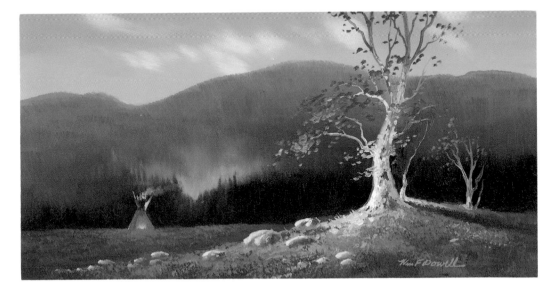

Using Cadmium Yellow Medium, Cadmium Orange and a speck of white, paint in the glow of the grasses in the foreground. The rocks are white and Cadmium Yellow Medium on the light side and Burnt Umber and the sky-blue mix on the dark side. Use the same colors on the tree trunks and to build more branches. Notice the sky-blue mix on the shadow side of the trunk. This is a soft bounce light that aids in the visual effect of the roundness of the trunk. Now, the leaves are painted as the final touches. Notice how the entire painting comes to life and the use of the warm grass and leaf colors against the cool, dark background colors gives us a rich use of those colors. In planning this painting, the use of complements across the wheel from one another was a major factor in creating a very successful final painting.

DEMONSTRATION 3 . . . "FOUR POLE CREEK"

1. WHITE +
 ULTRAMARINE
 BLUE

2. BURNT
 UMBER +
 ALIZARIN
 CRIMSON

3. WHITE +
 CADMIUM
 YELLOW
 MEDIUM

4. WHITE +
 CADMIUM
 RED LIGHT

After sketching in the main subject matter, mix #1 and paint it into the middle sky. Then with a touch of #2, darken the sky slightly at the top. Mixture #3 is used for the horizon glow and #4 is the pink cloud. After these colors are placed to your satisfaction, soften the harshness of any rough brush strokes with a very soft blender brush. Do not soften too much, however, as it will then lose the atmospheric feeling and look like the paint was applied with an airbrush. Airbrushes are wonderful tools, but here we want to see the subtle brush strokes so it appears to be loosely but softly painted.

5. #2 +CADMIUM
 YELLOW
 MEDIUM

6. WHITE +
 CADMIUM
 RED LIGHT

7. WHITE +
 CADMIUM
 YELLOW
 MEDIUM

#7

G
R
E
Y

#6

#1

With #5, paint in the block forms of the foliage and in the darker areas add a little #2 for the back supporting shadow masses. Using a combination of #6, #7 and #1, mix a soft grey and paint the sand in the foreground. This combination of grey can be altered to be warm or cool, depending on the mixture. It is very versatile since you are using the three primary colors when you are mixing this grey. With the three primaries, how can we go wrong? Paint in the water with #1 and a combination of white and Cadmium Yellow Medium. As you move along the bank, add #6 to the #1 and paint in the purple glow in the water.

CADMIUM
YELLOW
MEDIUM

PERMANENT
GREEN
LIGHT

#6

#2

CADMIUM
RED LIGHT

#2

LEMON
YELLOW

PERMANENT
GREEN
LIGHT

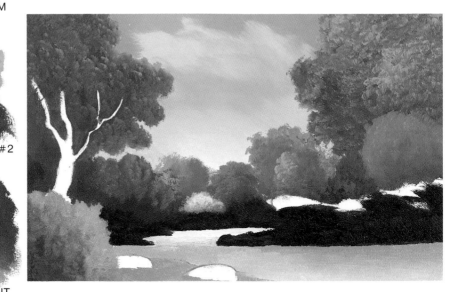

With Cadmium Yellow Medium, Permanent Green Light and mix #2, paint in the various yellow green colors of the foliage, trees, and shrubs. Mixes #2 and #3 plus Cadmium Red Light are the color mixtures which make up the warmth of the reddish bushes. Lemon Yellow and Permanent Green Light, plus some #2 are the light, bright yellow greens in the foliage and grasses. With the color swatches at the left as a guide, you can create endless mixtures that are useful in the painting as secondary colors.

WHITE +
LEMON
YELLOW

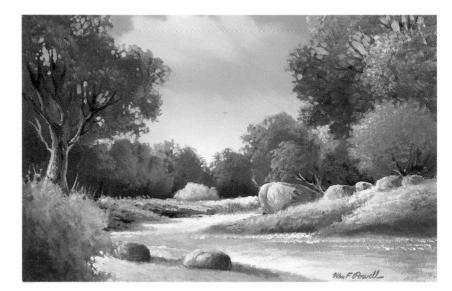

White plus Lemon Yellow is the only mix in this step. It is used to intermix with the other colors we already have. Using all of the mixtures, now is the time to complete the painting by putting in the details. Paint round boughs in the trees with the use of these dark and light colors. Use the warm and cool greens and bronze greens. Paint a few indications of individual leaves on some areas of the bushes and trees. Each of us likes or dislikes detail to a different degree. Please yourself in your painting and put in finishing details to your own liking.

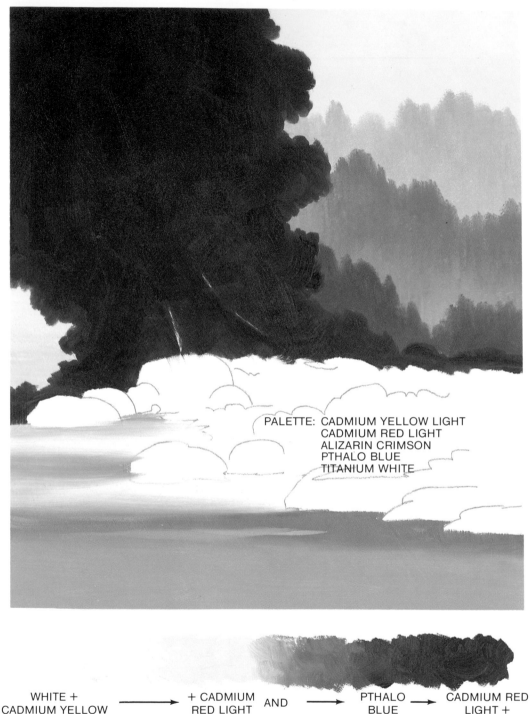

PALETTE: CADMIUM YELLOW LIGHT
CADMIUM RED LIGHT
ALIZARIN CRIMSON
PTHALO BLUE
TITANIUM WHITE

| WHITE + CADMIUM YELLOW LIGHT | → | + CADMIUM RED LIGHT | AND | → | PTHALO BLUE | → | CADMIUM RED LIGHT + PTHALO BLUE |

Using the mixing guide above, paint in the areas of the subject as shown. This is a very simple palette using the three primary colors of the color wheel – yellow, red and blue. The Titanium White is used as always to control the values by lightening a color. By first blocking in the dark masses, we can then create dimension by painting in the lighter and brighter greens and sunlight colors.

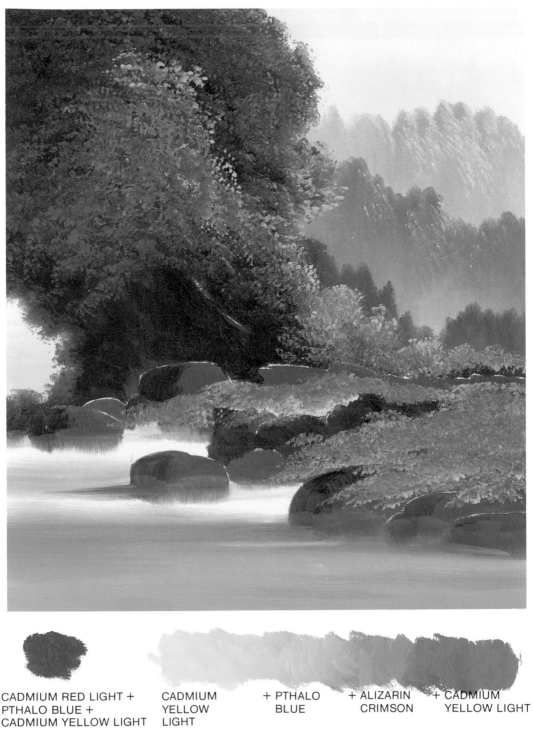

CADMIUM RED LIGHT +
PTHALO BLUE +
CADMIUM YELLOW LIGHT

CADMIUM
YELLOW
LIGHT

+ PTHALO
BLUE

+ ALIZARIN
CRIMSON

+ CADMIUM
YELLOW LIGHT

The first mix is the purple from the previous step plus lots more Cadmium Yellow Light. Paint the land and rock masses. Start painting the effects of sunlight striking the leaf and foliage forms. Do not go directly to the brightest lights first. Work up to them from the darker values. This aids in the depth of the forms. Start building the lights by using the mixture on the right side and work to the Cadmium Yellow Light on the left. While forming the boughs of the trees, paint a little past the outline and break the strokes so they appear to be little leaf forms.

55

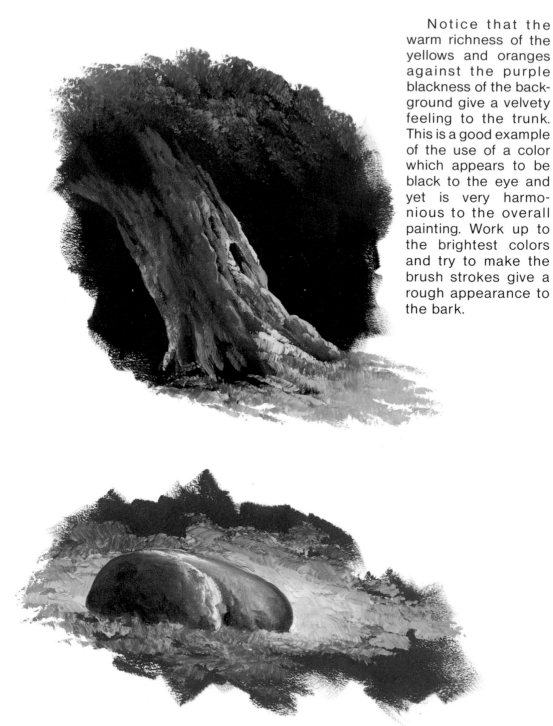

Notice that the warm richness of the yellows and oranges against the purple blackness of the background give a velvety feeling to the trunk. This is a good example of the use of a color which appears to be black to the eye and yet is very harmonious to the overall painting. Work up to the brightest colors and try to make the brush strokes give a rough appearance to the bark.

The rocks in this painting are basically just suggestions rather than laboriously crafted ones. The light of the grass and dark of the rock give the overall outline of form. After we have the form established, we can establish dimension by adding the touches of light where we wish. The white and Cadmium Yellow Light are the highlights. Paint a glow behind the rock using small vertical strokes and the grass colors.

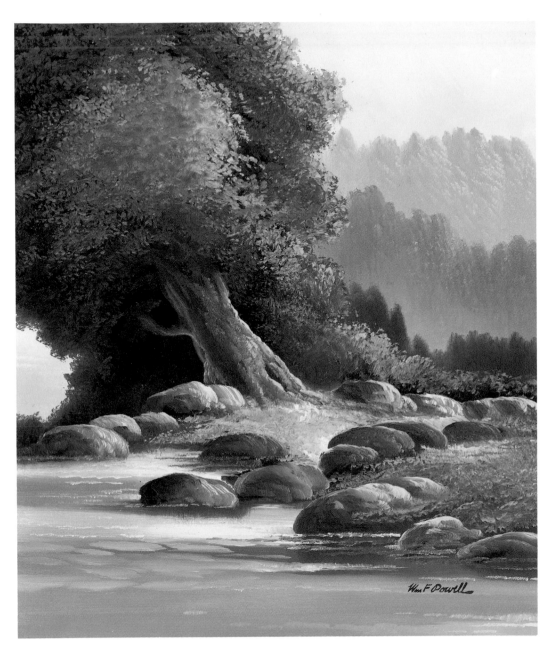

Now, using all of the colors previously mixed, go for the final by painting in all of the details to your own satisfaction. The orange color spotted here and there is a combination of a little Alizarin Crimson and Cadmium Yellow Light. Add some of this orange sparingly to the greens of the trees and grasses. Ripples on the water are a base of the yellow and white we used in the sky. Also, a little Alizarin Crimson and Pthalo Blue were added for the light purple. Keep this scene soft as the colors, even though bright in places, dictate the soft mood. Yellow is the dominant color and purple is the dark accent.

DEMONSTRATION 5... "DOWN HOME WINTER"

1. WHITE +
 PRUSSIAN
 BLUE

2. WHITE +
 ULTRA-
 MARINE
 BLUE

3. BURNT
 UMBER +
 ALIZARIN
 CRIMSON

4. WHITE +
 CADMIUM
 ORANGE

After sketching the subject, start painting in the sky using the cool Prussian Blue and white mixture. White and a speck of Cadmium Orange are used in the clouds and add to the atmospheric effect in the sky. Using Burnt Umber and Alizarin Crimson, with a touch of #1, paint in the middle ground bushes. Watch the values!

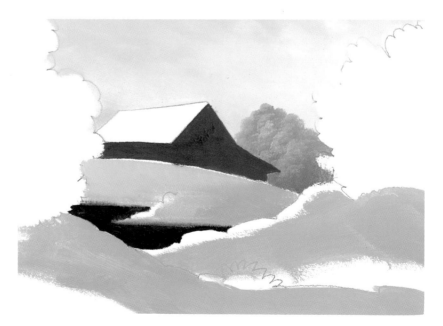

Using mixture #3, paint in the face of the barn and the siding too. Leave the roof blank at this time. Now we have to paint in the pond with pure Prussian Blue. Next, using the two blue mixtures, #1 and #2, paint the underbase blue for the snow. Notice that even in the under painting we set the source of light by using the lighter Prussian Blue on the left of the far bank.

5. WHITE +
 CADMIUM
 YELLOW
 LIGHT

6. #2 + #3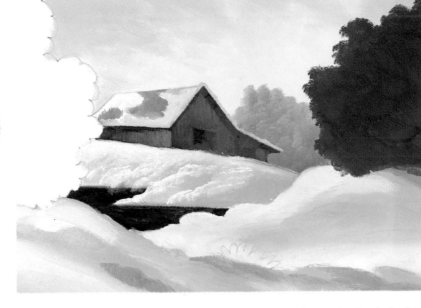

With white and Cadmium Yellow Light (#5) and a speck of #3, paint the dark of the barn roof. Now we paint the side of the barn with pure Cadmium Red Light. Work it into the wet #3 that is already there. Leave a dark space under the eaves for shadows and brush it on using a vertical stroke to indicate board siding. Using a blue grey by mixing #2 and #3, paint some of the shadow snow. Once you have the barn and its snow bank nearly finished, paint in the trees on either side using pure #3.

All of the details that you see here were painted with only the few colors that we have already mixed. The tree trunks are a combination of Cadmium Red Light, #3 and #4. The warmth of the Cadmium Yellow Light mixture (#5) is the lightest of the highlight colors. No pure white is used in this snow scene, as it would only pale all of the sunlight glow colors of #4 and #5. Take your time and paint in the details to please yourself. Hope you enjoy this little scene!

59

DEMONSTRATION 6... "MOUNTAIN PARADISE"

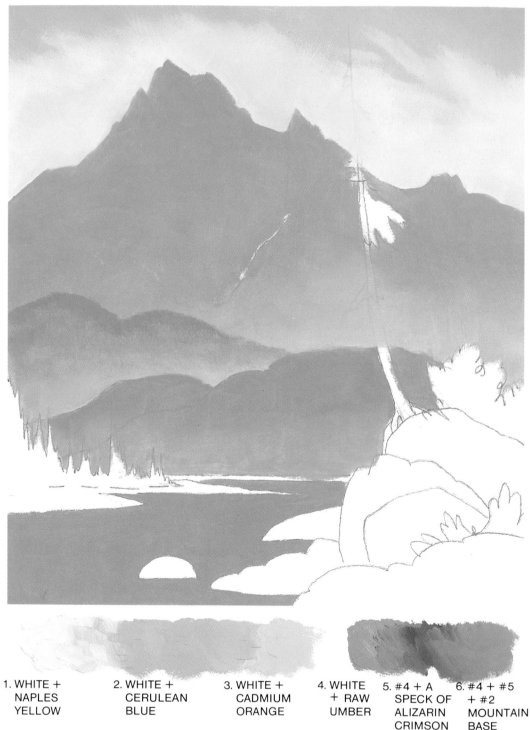

1. WHITE +
 NAPLES
 YELLOW

2. WHITE +
 CERULEAN
 BLUE

3. WHITE +
 CADMIUM
 ORANGE

4. WHITE
 + RAW
 UMBER

5. #4 + A
 SPECK OF
 ALIZARIN
 CRIMSON

6. #4 + #5
 + #2
 MOUNTAIN
 BASE

Use #1 mix and paint in the horizon glow behind the mountain. Then add a speck of #3 at the lower right. Paint in the basic sky color using #2. A tiny speck of Alizarin Crimson plus #4 mix is used in the corners of the sky to give a soft vignette feeling. Mixture #5 plus a little #2 mixture are the colors used to block in the mountain. Use the sky colors to lighten the back mountain. Remember, if we add a touch of the color that is behind an object, that object will recede to the distance. By adding sky color to the mountains they will recede, giving us a feeling of natural aerial perspective.

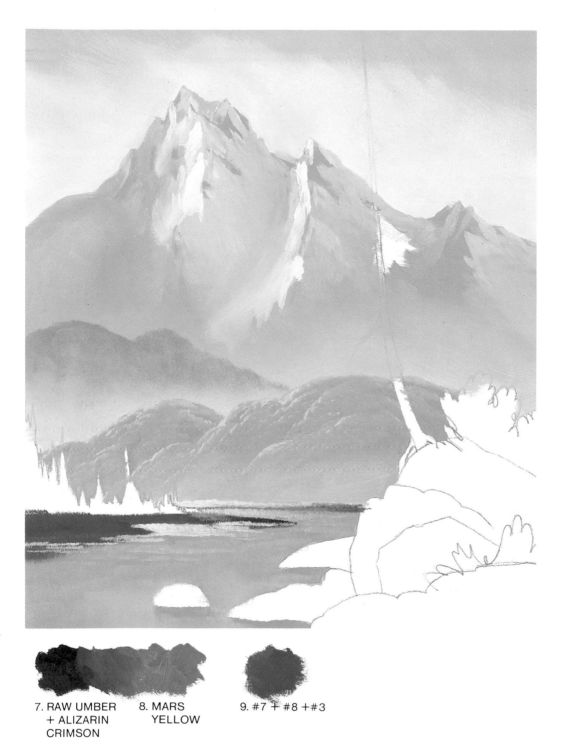

7. RAW UMBER
 + ALIZARIN
 CRIMSON

8. MARS
 YELLOW

9. #7 + #8 + #3

Use #2 blue and start painting in the reflections in the water. Then start building the planes and forms that will give our mountain depth and perspective with colors #1, #2 and #3. Mixture #3 is the glow color on the foothill and #2 is used on the shadow side. Mix Raw Umber and Alizarin Crimson together until you get sort of a fake Brown Madder. This is mixture #7. It is a beautiful dark that is used to deepen other colors in the painting in a very rich manner. Mixture #8 is pure Mars Yellow. For the distant land mass, we mix #9. It is #7 + #8 with a little #3 for lightness. Be very careful to get the right value as the value is so important.

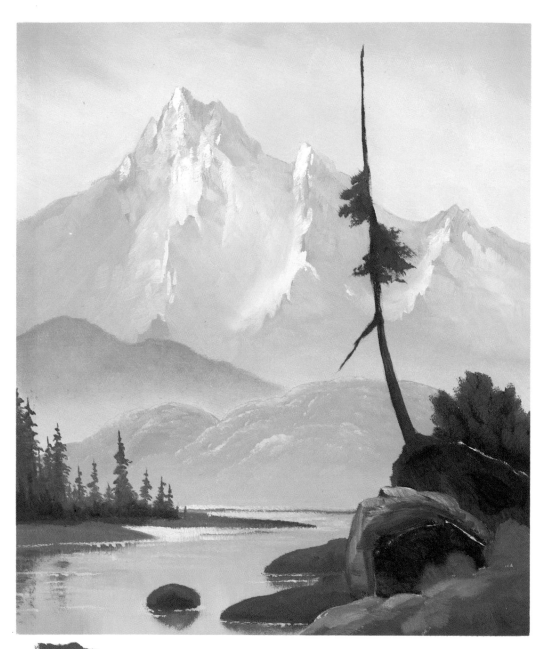

10. MARS YELLOW +
 ULTRAMARINE BLUE

Continue with the detail on the mountain using a tiny amount of pure white for accent only. Be careful not to over use the white. It would destroy all of the softness we have worked so hard to achieve. Using mixes #7 and #8, block in the dark masses of the rocks, bushes and the main tree. Use a little #1 and #3 to change the values and therefore start the dimensional form. Mixture #10 is Mars Yellow and Ultramarine Blue. Using #10 along with the other mixes, paint in the starting shapes of the bushes and trees. For distance, add a little of the #2 sky blue.

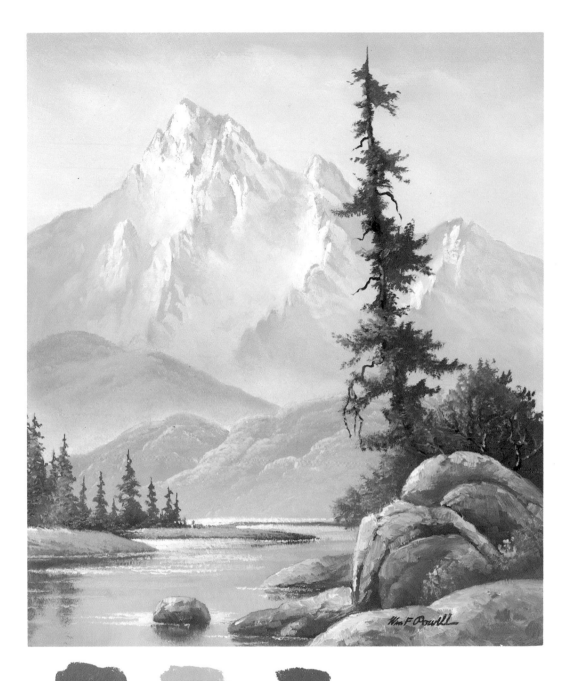

11. NAPLES YELLOW
 + ULTRAMARINE
 BLUE

12. #11 +
 CADMIUM
 YELLOW LIGHT

13. MARS YELLOW
 + CADMIUM
 ORANGE

Mix Naples Yellow and Ultramarine Blue for #11 and paint in the middle value of green on the bushes, tree and grasses. This not only gives more life to the subject but adds to the form. The highlight greens are painted with #12. Mixture #13 gives the warming tints on the rocks, trunks and branches, and any other spots you may wish to warm with it. Finish the painting by putting in all of the details using combinations of all of the 13 colors mixed.

" FISH FOR SUPPER...? "

In this painting I feel that the subject calls for a technique that allows me to paint more detail. I really enjoy detail and can spend hours concentrating on a small area. Even though I am paintng detail, I must not forget the overall painting and subject or I may lose the statement. When painting detail we must not become impatient; it is time consuming but rewarding.

Here, I painted each leaf individually and then went back and painted the highlights individually as needed. The main subject is the racoon with the fish being a part of the story. The greatest detail has been painted onto the racoon with a secondary glow light around the fish to draw attention to that area. A mixture of white and Cobalt Blue was used to paint the surface effects on the water and around the rock. I also employed the use of glazing in this painting and here we must be patient between drying times (see GLAZING, pages 44-45).

The colors used in this painting are Cobalt Blue, Cerulean Blue, Alizarin Crimson, Burnt Umber, Cadmium Orange, Cadmium Yellow Light, Naples Yellow and Titanium White.

I hope that you have enjoyed this book and that it will be a constant source of information for you in your continuing painting and study of color.